Elizabeth Taylor

THE LIFE OF A HOLLYWOOD LEGEND

KATY SPRINKEL

TRIUMPH
BOOKS

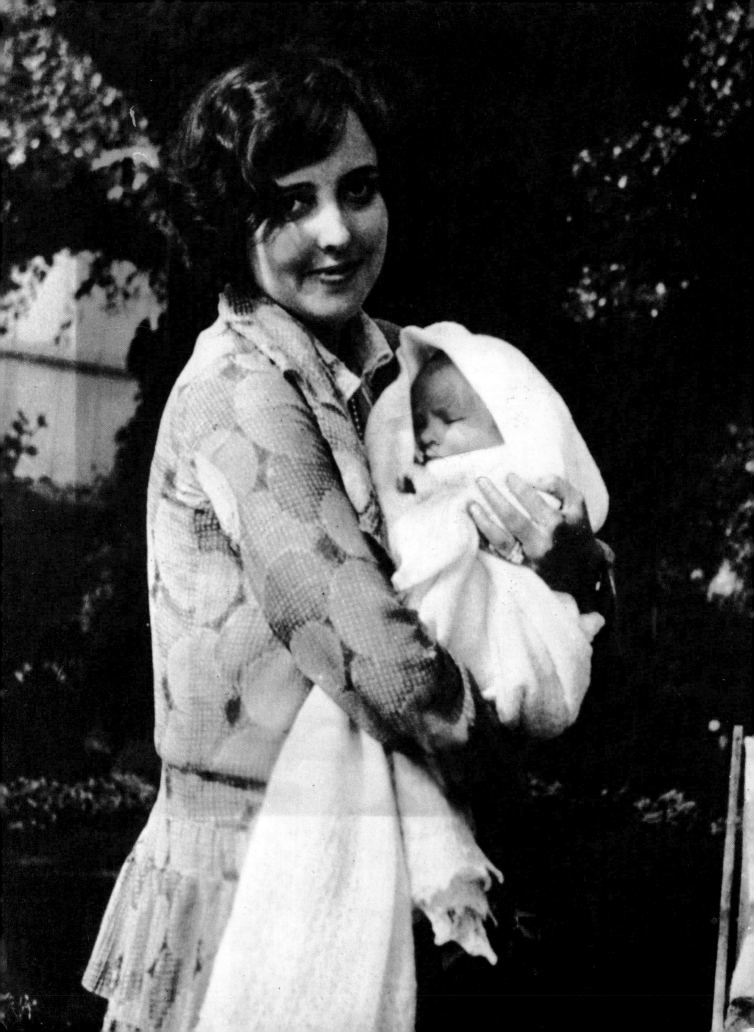

A Star Is Born

From her earliest days, it seemed Elizabeth Rosemond Taylor would take after her mother.

Sarah Warmbrodt left her native Arkansas City, Kansas, for Los Angeles in 1922 with her sights set on being a star. She quickly changed her name to Sara Southern and embarked on a career as a stage actress. Success catapulted her to New York, where she found something else entirely: a husband.

Francis Taylor, also a native of Arkansas City, was working in New York at an art gallery owned by his uncle. He and Sarah had dated briefly back home, but nothing had come of it. It was when they reunited in New York, purely by chance, that their romance took hold. The two soon married. Francis accepted the task of opening a new gallery in London, and Sara gave up acting for good.

On February 27, 1932, Elizabeth Rosemond Taylor entered the world. Sara recalled her daughter's debut in an article she wrote for *Ladies' Home Journal* in 1954: "As the precious bundle was placed in my arms, my heart stood still. There, inside the cashmere bundle, was the *funniest* looking baby I had ever seen! Her hair was long and black. Her ears were covered with long black fuzz...and her tiny face was so tightly closed it looked as if it would never unfold."

It was an unlikely beginning for the woman who would be universally regarded for her beauty.

The Little Princess

⚹ Young Elizabeth was the apple of her mother's eye. So much so that many observers noted how little attention was given to Howard, Elizabeth's older brother. Whatever the reason, Elizabeth was indeed her mother's little princess. And formal training to make Elizabeth into a proper lady began immediately.

She was enrolled in dance classes as early as age two. By age four, she was performing onstage for the likes of the royal family, including the Duchess of York and her daughters, Princesses Elizabeth (now Queen Elizabeth II) and Margaret.

"It was a marvelous feeling," Elizabeth wrote in her 1965 autobiography, *Elizabeth Taylor: An Informal Memoir*, "the isolation, the hugeness, the feeling of space and no end to space, the lights, the music—and then the applause bringing you back into focus, the noise rattling against your face."

But as thrilling as it may have been for young Elizabeth, it was Sara who was intoxicated by her daughter's star quality. Elizabeth's beauty was infectious. People would stop them on the street and marvel at the child's brilliant violet eyes. *You simply must get her into the movies*, they gushed. *She's the spitting image of Vivien Leigh!*

The notion took root in Sara's mind, but it wasn't until the Taylors returned to the United States that the idea began to flourish.

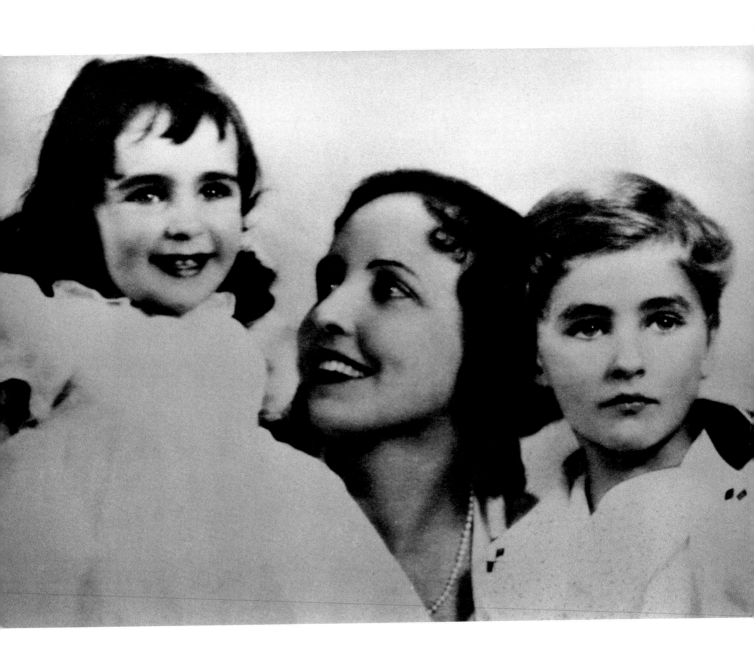

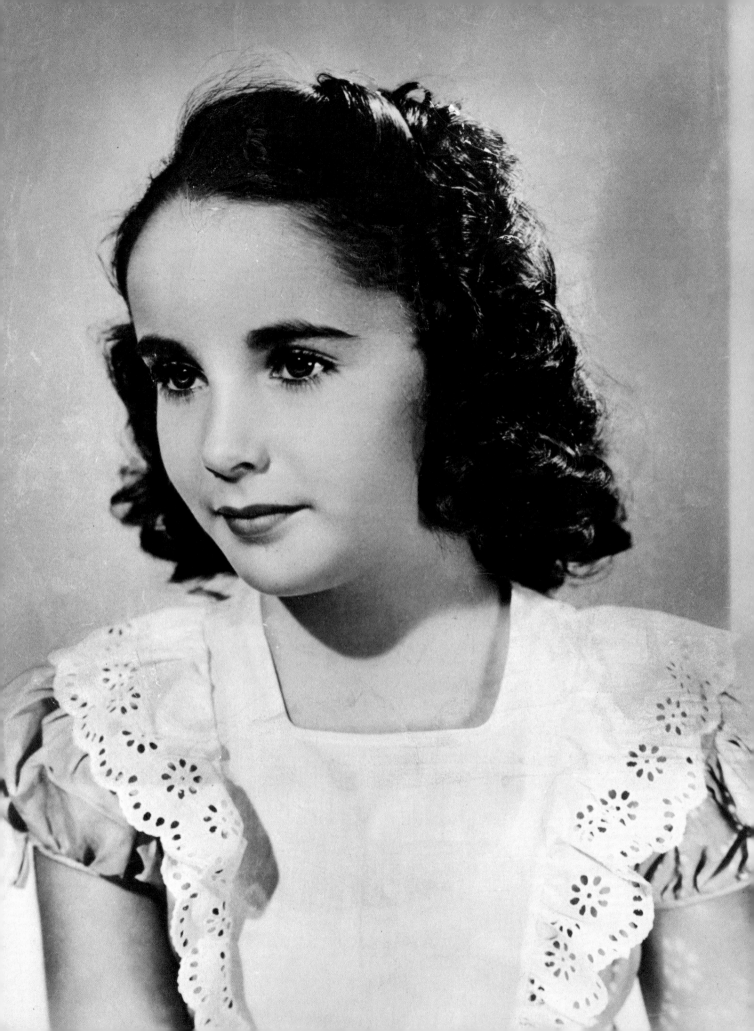

A World at War

...

As the decade came to a close, tensions in Europe were mounting and the entire world seemed on the brink of war. Closer to home, the children had become the objects of ridicule at their schools, castigated for their American accents. Sara had also been slighted by the British gentry and was growing weary of the English caste system. But it was Hitler's increasing march across Europe that crystallized their decision; it was time for the Taylors to return home.

The family set sail for America on the ocean liner *Manhattan* on April 3, 1939. Part of the onboard entertainment during the voyage was the screening of a new Hollywood movie, *The Little Princess* starring Shirley Temple. It was an event that may well have had a huge impact on the young girl's life.

Sara remembers her daughter being enthralled by the movie, completely held in rapt attention. The pint-sized actress was particularly mesmerizing. After the screening, Elizabeth turned to her mother and told her that she, too, might want to be a performer. Then, without missing a beat, she added, "I don't want to be a movie star. I want to be an actress."

California, Here We Come

With uncertainty about the war clouding the business abroad, Francis decided to relocate his London gallery back in the United States, and found prime real estate in the Beverly Hills Hotel in Los Angeles. Not surprisingly, he catered to an upper-class clientele, including many movers and shakers in the movie business.

In California, the familiar chorus rang even louder: *that kid oughta be in pictures*. Hedda Hopper, the famous Hollywood gossip columnist and one of Taylor's gallery clients, suggested young Elizabeth for the part of Bonnie Blue Butler, Scarlett O'Hara's daughter in the forthcoming *Gone with the Wind*. Francis would hear nothing of it; he had no intentions of entering his child into show business.

For two years her parents resisted the call, but finally Hollywood won out. At the age of nine, Elizabeth Taylor signed her very first film contract, with Universal. Hedda Hopper heralded the news in her column, proclaiming, "by all hereditary rights, Elizabeth Taylor should be a smash success." Unfortunately, her success at Universal was short-lived, and she was released from her contract just six months later.

Fate soon intervened again. The lead actress in *Lassie Come Home* needed to be replaced—and in a hurry. The studio was clamoring for a 10-year-old girl who could do an English accent. Elizabeth got the call, and a contract with MGM. It was her first major role. She starred opposite Roddy McDowall, who would remain a friend for life.

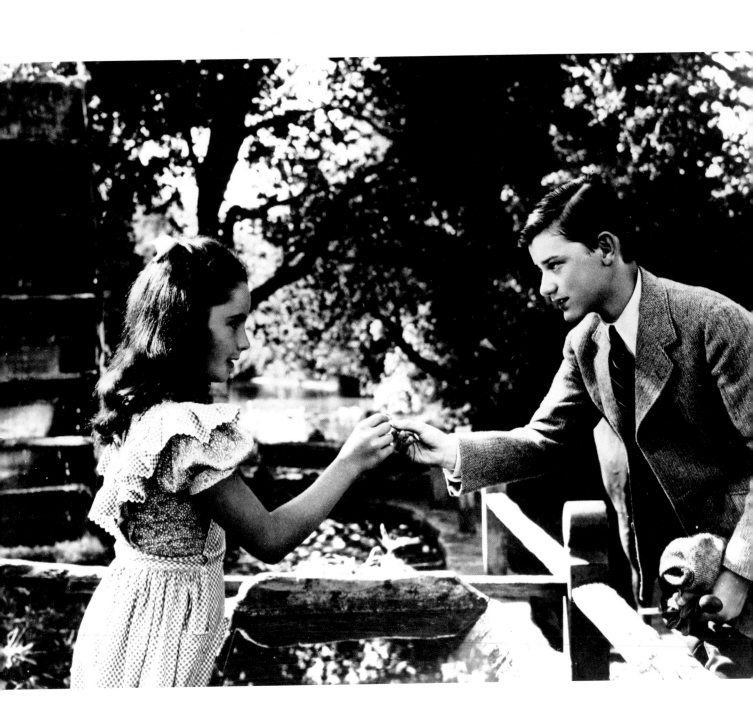

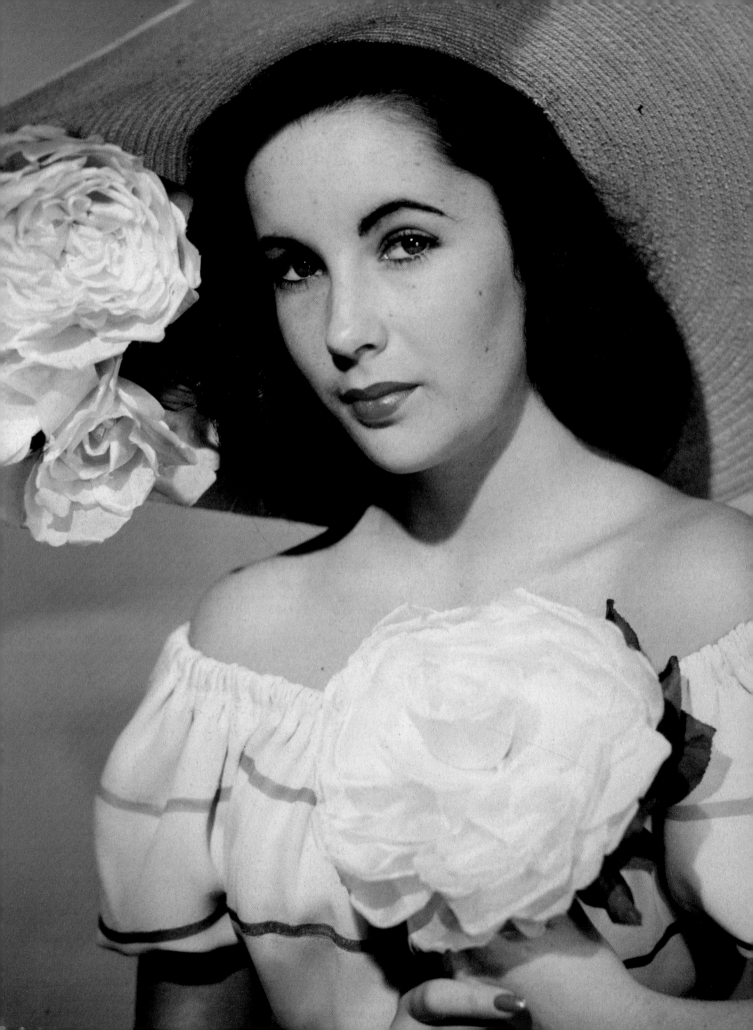

"Elizabeth Taylor is one of the most beautiful children I have ever seen."

HEDDA HOPPER

In the Saddle

�֍ The role of Velvet Brown seemed tailor-made for Elizabeth. She was an energetic child who loved animals and being outside. Moreover, she was a girl who made her own destiny. Taylor, then an 11-year-old actress on the set of her second film, *The White Cliffs of Dover*, lobbied the director, Clarence Brown, for the lead in his forthcoming picture, *National Velvet*.

The film, based on the book by Enid Bagnold, tells the story of a young girl who is bound and determined to make her dream come true. She wants to own the horse she sees running wild through the countryside, which she has affectionately named "Pirate". Velvet does follow that dream, and through the help of a jaded former jockey (played by Mickey Rooney), she trains Pirate and eventually rides him in England's prestigious Grand National.

"What impressed me most...was her absolute conviction that the picture would be made and would provide a vehicle for her eventual stardom," Brown said to C. David Heymann in *Liz*. Of course, she was right. The role would gain her wide acclaim from critics and audiences, and it would be the platform from which she launched her subsequent career.

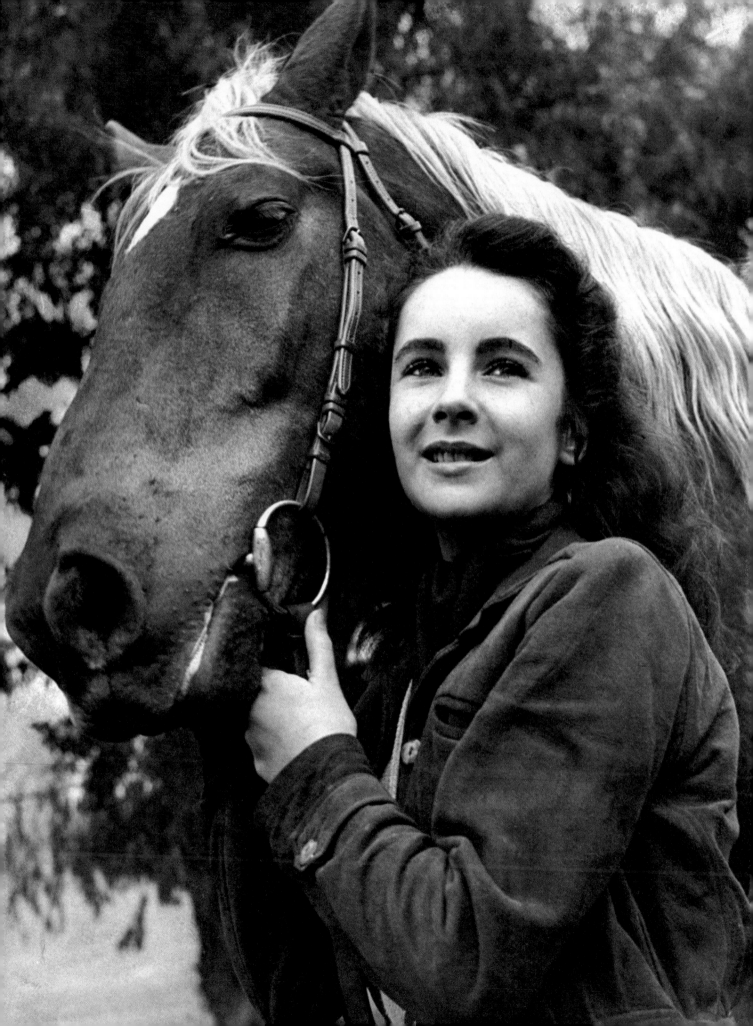

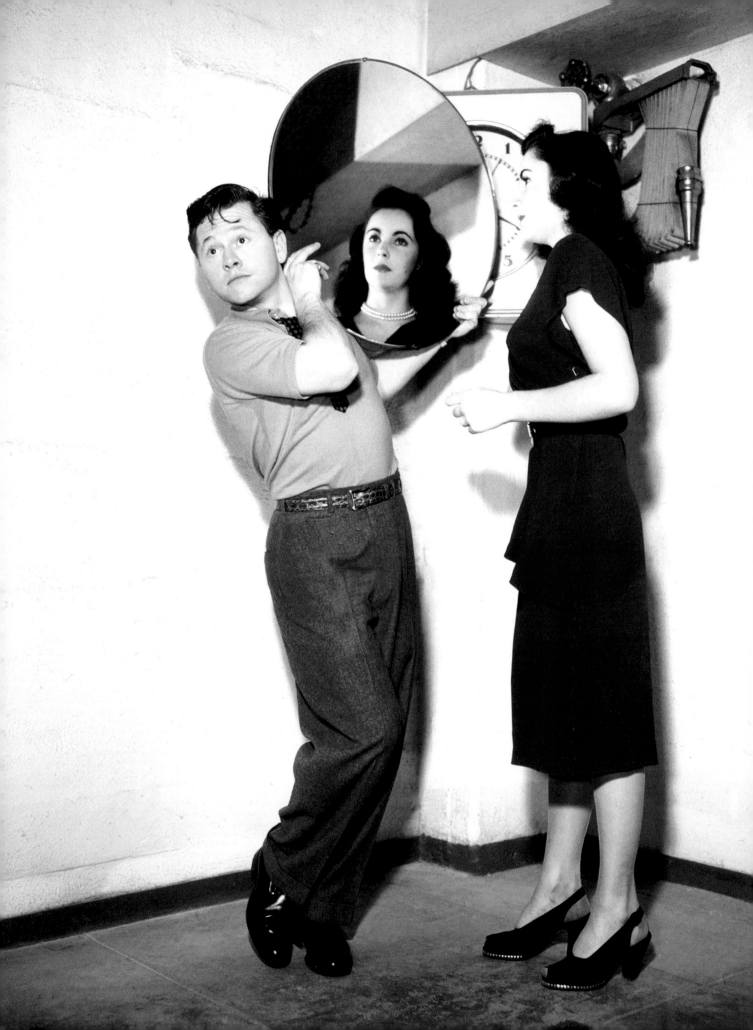

Meeting Mickey

✳ An actor since the age of six, Mickey Rooney was the perfect role model for Elizabeth who, until *National Velvet*, had cut her teeth on only minor roles and had yet to receive much formal training. At the age of 22, Rooney, 12 years Taylor's senior, was already an old pro in show business. Rooney gave Taylor some of her earliest acting advice. The two would remain friends for the rest of their lives.

Critics and audiences agreed that Elizabeth's performance as Velvet Brown—and in particular the scenes she shared with Rooney's jockey Mi Taylor—were extremely affecting. Even Clark Gable, MGM's biggest star at the time, anointed Taylor, describing her performance as the best juvenile work in movie history.

Years later, Taylor would say that the role was one of her two favorites, along with her blistering performance in *Who's Afraid of Virginia Woolf?*. Though she freely admitted, "I clearly played myself. It wasn't a question of portraying a character. I was in real life an extension of Velvet Brown."

Lassie and Nibbles

✳ In the wake of the overwhelming success of *National Velvet*, MGM fast-tracked Taylor's next vehicle. The studio recognized her animal magnetism, and quickly put another Lassie movie into production.

Courage of Lassie is a strange contribution to the war effort, a sort of *Best Years of Our Lives* for the children's set. In the film, Lassie's puppy becomes separated from her caretakers, including young Kathie (played by Taylor). He is enlisted in K-9 duty and sent overseas to fight in the war effort. When the pup finally comes home, he is greeted with some trepidation. Some think the dog is a danger, even violent. Taylor's performance as Kathie anchors the film and provides it with its heart.

Though the film did not perform well at the box office, it did have an upside. During the production of the film, Taylor discovered a chipmunk running around on set, which she caught and named Nibbles. Taylor was fond of chipmunks and regularly played with them outside her home in Beverly Hills. The on-set antics got the right person's attention, and soon Taylor was a published author. *Nibbles and Me* was published in 1946, the first of her authorial works.

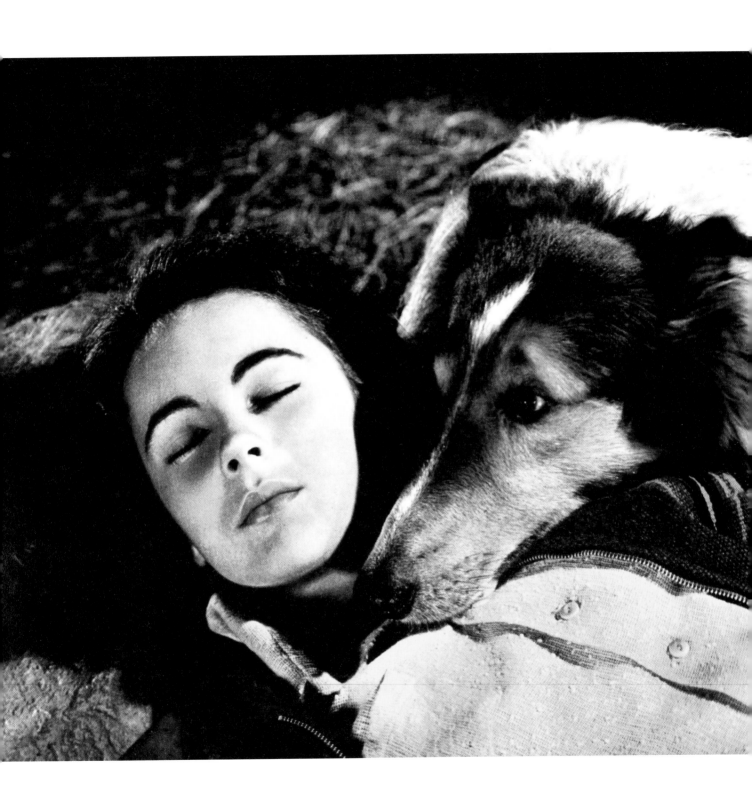

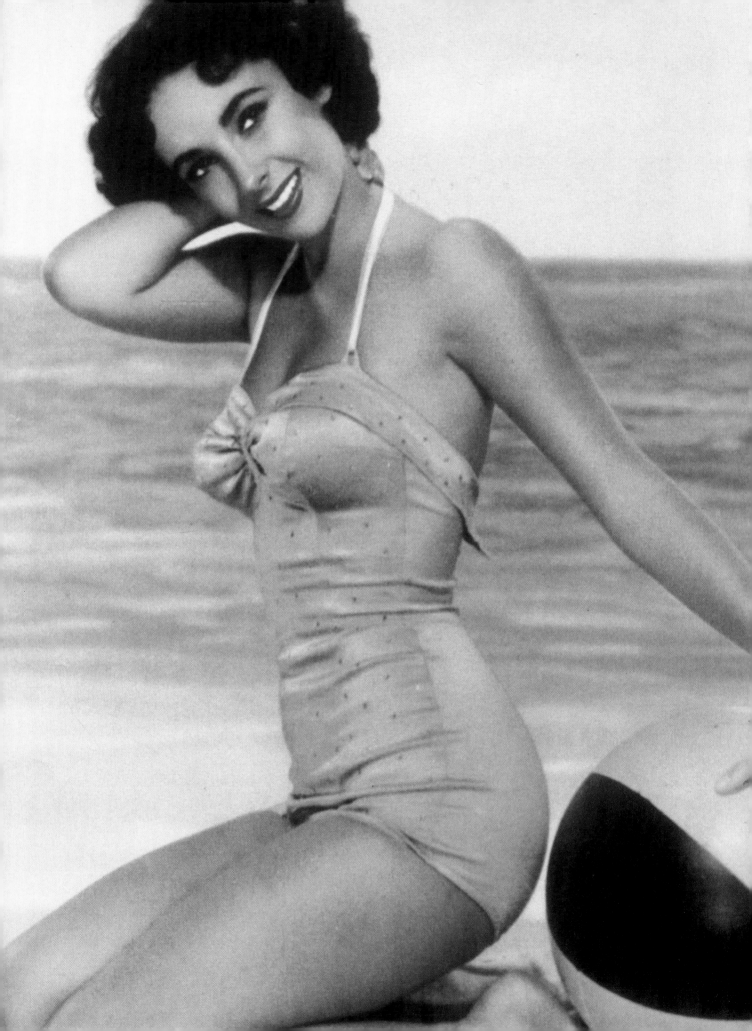

No Longer a Girl, Not Yet a Woman

✄ By age 16, Elizabeth was no longer a pretty child. She had blossomed into a beautiful woman. MGM, eager to market their star for her exotic looks, started taking provocative photographs of the actress at age 15. She bared as much as was legal at the time, and was rewarded with an $18,000 raise.

They weren't the only ones eager for her to grow up. "As a child I had been dying to get my period because it meant I was growing up," she said. "I loved every second of puberty."

But for as much as the studio shamelessly marketed her sexuality, they guarded her virginity with a fervent vigilance, not even letting her go to the bathroom for fear of her getting taken advantage of. It was a lonely adolescence for Taylor, whose only social interactions came on set or under strict supervision from the studio brass.

Still, to the public, those sparkling violet eyes were indelible. And it was that beauty on which MGM had hitched their fates. Taylor was the young face of the studio, for better or worse.

"[Elizabeth] was a lady who gave herself to everyone."

MICKEY ROONEY

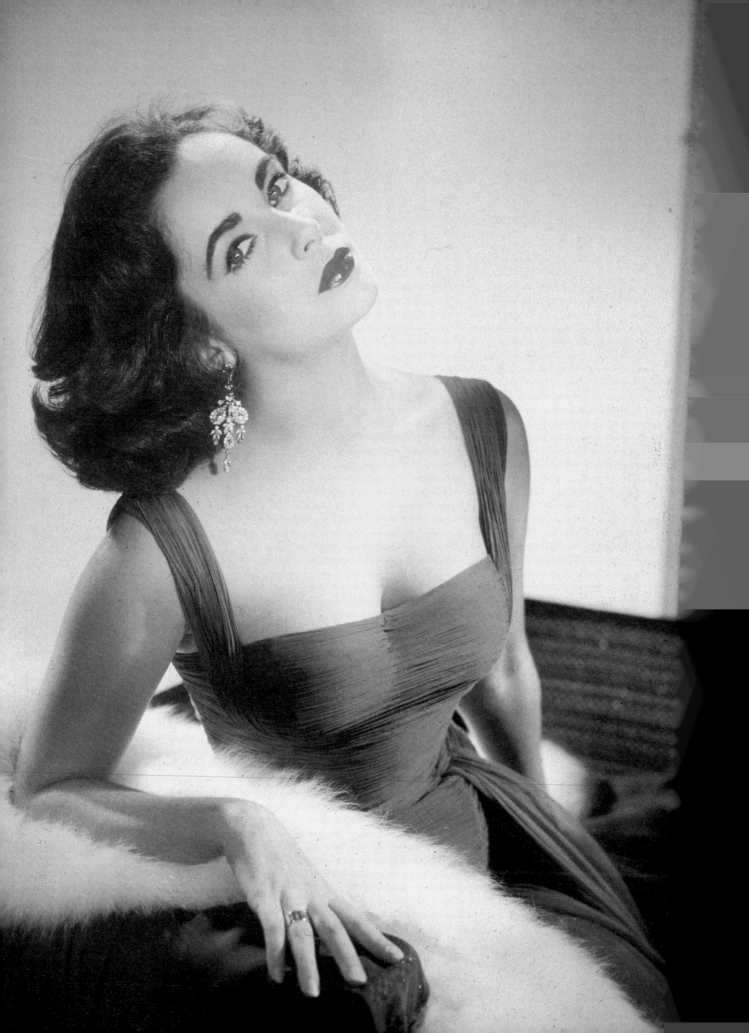

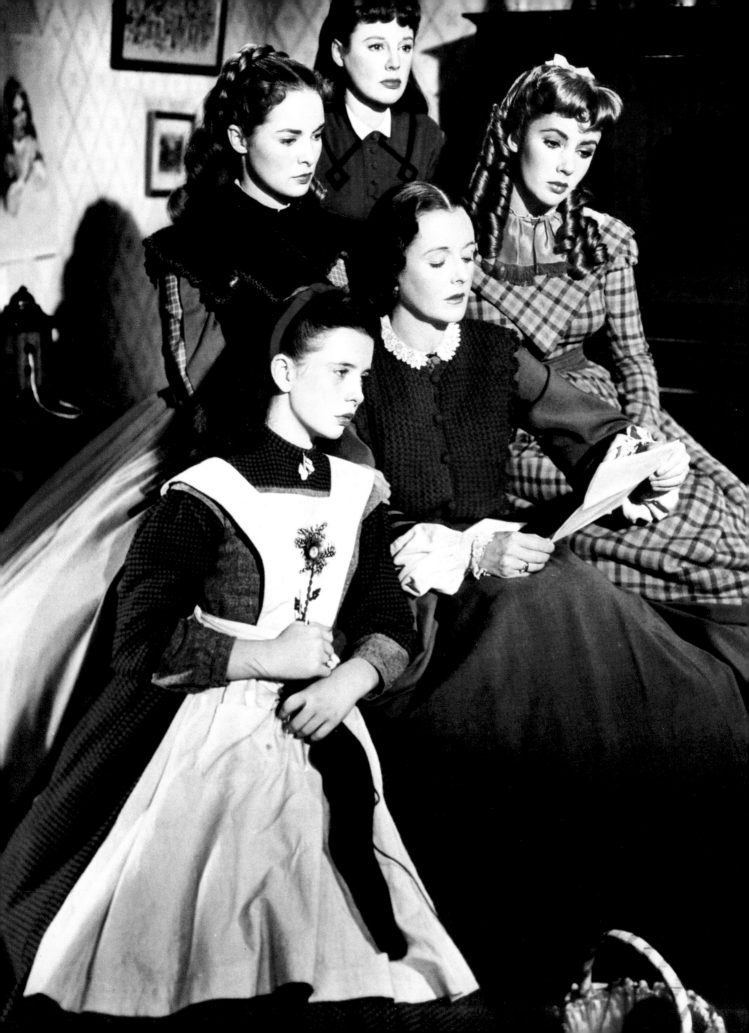

Among MGM's Little Women

In the summer of 1948, Elizabeth was dispatched to play Amy in the adaptation of Louisa May Alcott's beloved classic, *Little Women*. Co-starring in the film were June Allyson, Margaret O'Brien, and Debbie Reynolds, with whom Taylor found an early kinship.

During the course of filming, Taylor did some of her first dating, doubling along with Reynolds and her date—and the requisite chaperones, of course. According to Reynolds, Taylor was still naïve about the opposite sex, hopeful for chaste and simple dates that "would never happen in her life."

It was during the filming of *Little Women* that Elizabeth developed her first crush, on co-star and future Rat Packer Peter Lawford. Unfortunately, the affection was not returned. But the event was in many ways an awakening for Elizabeth, who discovered the power of romance. As it happened, love wasn't trailing that far behind.

Elizabeth the Bride

✳ As fate would have it, Elizabeth's first turn as a bride came not in real life, but in the movies. *Father of the Bride* was directed by Vincente Minnelli (father of Liza Minnelli, with whom Taylor would later forge a close friendship). The film was a vehicle for Spencer Tracy, who played the titular role, to exercise his comedic chops as a father unwilling to lose his daughter to adulthood.

The 17-year-old Elizabeth was every inch the blushing bride. If she was convincing in her role, it could have been that the real thing was also happening behind the scenes. Just hours after filming wrapped, she announced her engagement to hotel heir Nicky Hilton.

The studio decided to delay release of the movie until Taylor's real-life wedding, which was effectively commandeered by the MGM execs, who took over every inch of the wedding planning. Taylor's $3,500 wedding gown was a gift from Louis B. Mayer. Famous costume designer Edith Head even designed Elizabeth's honeymoon wardrobe.

The movie was a smash success, receiving Academy Award nominations for Best Picture, Best Screenplay, and Best Actor for Tracy. Taylor's real-life marriage, on the other hand, was another story.

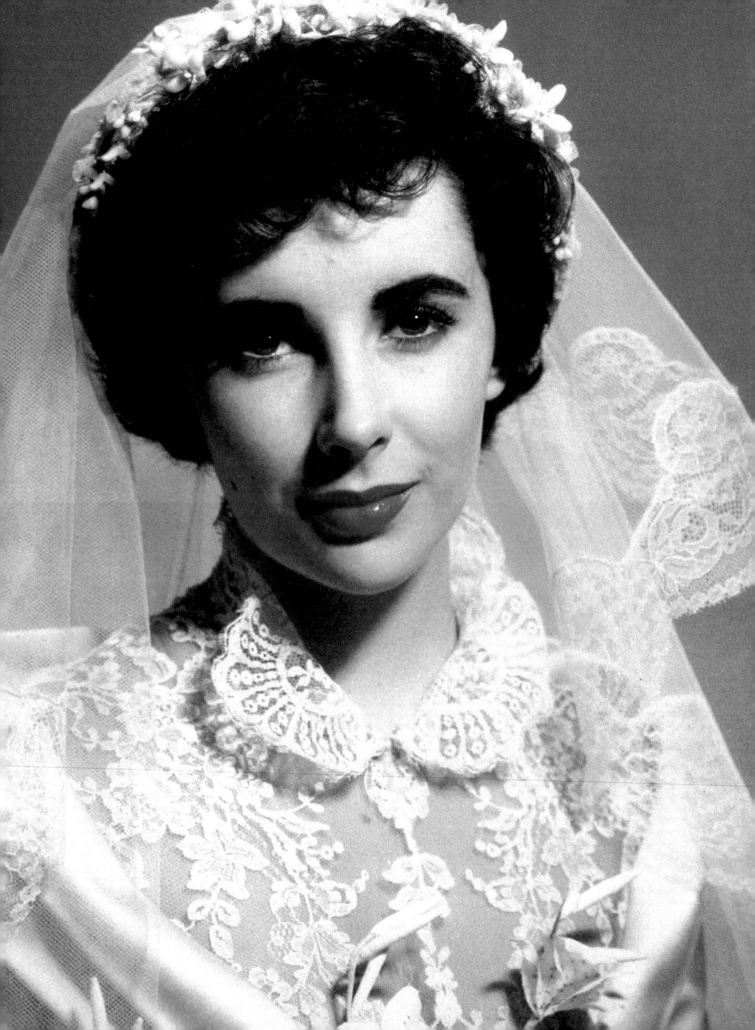

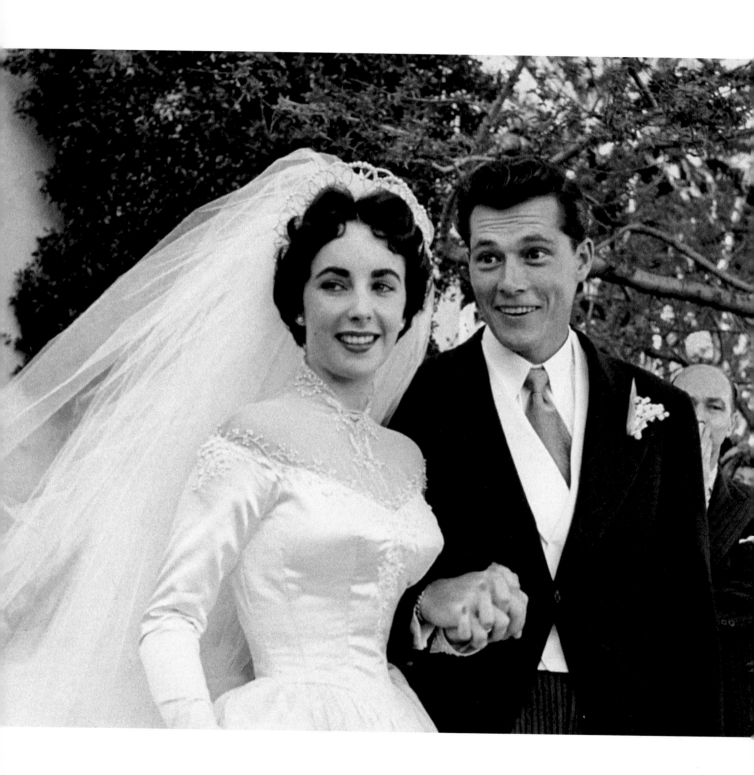

Wedding Bells

✳ Conrad Nicholson Hilton Jr. was by all counts one of the most eligible bachelors in Los Angeles. Tall, handsome, and heir to one of the biggest fortunes in America—the Hilton hotel empire—"Nicky" was exceedingly charming and well-cultured. When he and Taylor met in 1949 on the set of her upcoming film, *A Place in the Sun*, the connection was instantaneous. After a brief courtship, the engagement was set.

Taylor's parents, resistant to let her marry so young, saw in Hilton the stability and social boost that the match proffered. So they gave their blessing.

Elizabeth believed that she was in love, but she was also desperate to break free of her mother's domineering control. She was also ready to explore more primal urges. "I always had a strict and proper upbringing, and that was absolutely necessary, living the existence I did," she later wrote. "The irony is that the morality I learned at home required marriage. I couldn't just have an affair. I was ready for love, and I was ready for lovemaking."

Life with Nicky

To outsiders, Elizabeth and Nicky were a fairy-tale couple, but in reality their life was marred from the start. Nicky was a violent-tempered man who had serious problems with gambling and drinking.

"I closed my eyes to any problems," Elizabeth said, "and walked radiantly down the aisle." But the young bride was terrified. "I wanted to run, I was so scared. I really had no idea what was coming."

What came was indeed scary. Nicky was prone to vicious outbursts of anger, and the couple was often observed having violent rows in public. She was the victim on physical and verbal abuse from her husband, who was also blisteringly jealous of the star's public adulation.

After just seven months of marriage, the couple separated. Elizabeth, who was a jewel in MGM's crown, did not seek alimony. "I don't need a prize for failing," she said at the time of the divorce.

The marriage was indeed a loss of innocence for Taylor. She poured herself into work again with renewed vigor, working indefatigably to erase the memory of her failed union.

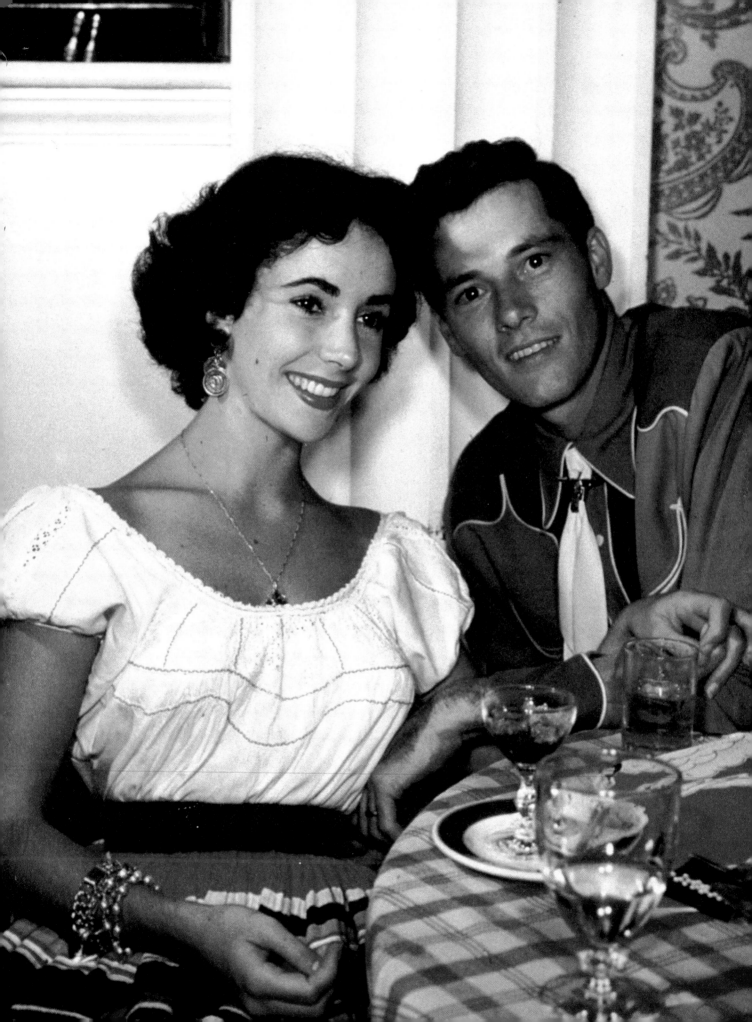

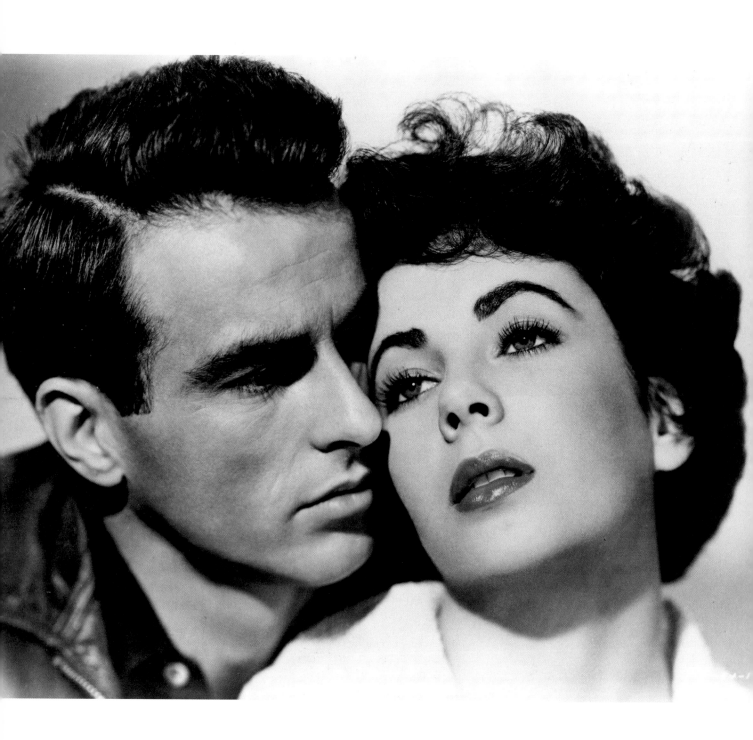

Montgomery Clift

On loan to Paramount, Elizabeth starred as the romantic lead opposite Montgomery Clift in George Stevens' *A Place in the Sun*. The movie, adapted from Theodore Dreiser's *An American Tragedy* is the stuff of film legends. Clift played a betrothed man who is torn by his love for another woman, played by Taylor. Their scenes together are some of the most passionate embodiments of young love ever committed to celluloid.

Monty and Elizabeth became extremely close during the production, though there was no romantic connection between them.

In a later interview with the magazine *The Advocate*, Taylor reflected, "I was 18 or 19 when I helped him realize that he was a homosexual, and I barely knew what I was talking about.... I loved Monty with all of my heart and just knew that he was unhappy. I knew that he was meant to be with a man and not a woman, and I discussed it with him.... It was very hard for men who wanted to come out of the closet in those days.... I didn't know that I was more advanced than most people in this town. It never occurred to me."

"We really loved each other, in the fullest, complete sense of the world," Taylor once told Barbara Walters.

The relationship was pivotal in Taylor's life. She would go on to become an outspoken public advocate for gay rights.

The Sweetheart of MGM

�֍ *A Place in the Sun* was a huge success in every sense of the word, and also marked the first time that Taylor's name would be featured above title. In her dramatic turn as the beautiful, wealthy vixen Angela Vickers, she also established herself as a serious dramatic actress to be reckoned with. Though she was snubbed come Oscar time, the film would end up with six nominations altogether. Her association with the movie proved her bankability as a leading lady.

She wrapped several projects in the early 1950s, including an adaptation of Sir Walter Scott's *Ivanhoe* and a string of other forgettable movies including *The Girl Who Had Everything, Love Is Better Than Ever, Elephant Walk, Rhapsody, Beau Brummel,* and *The Last Time I Saw Paris*.

Even so, the image of Elizabeth Taylor was universally recognizable. She was a beauty, but more important, she was a movie star. Photographers had already anointed her "the most beautiful woman in the world." All she needed now was another hit.

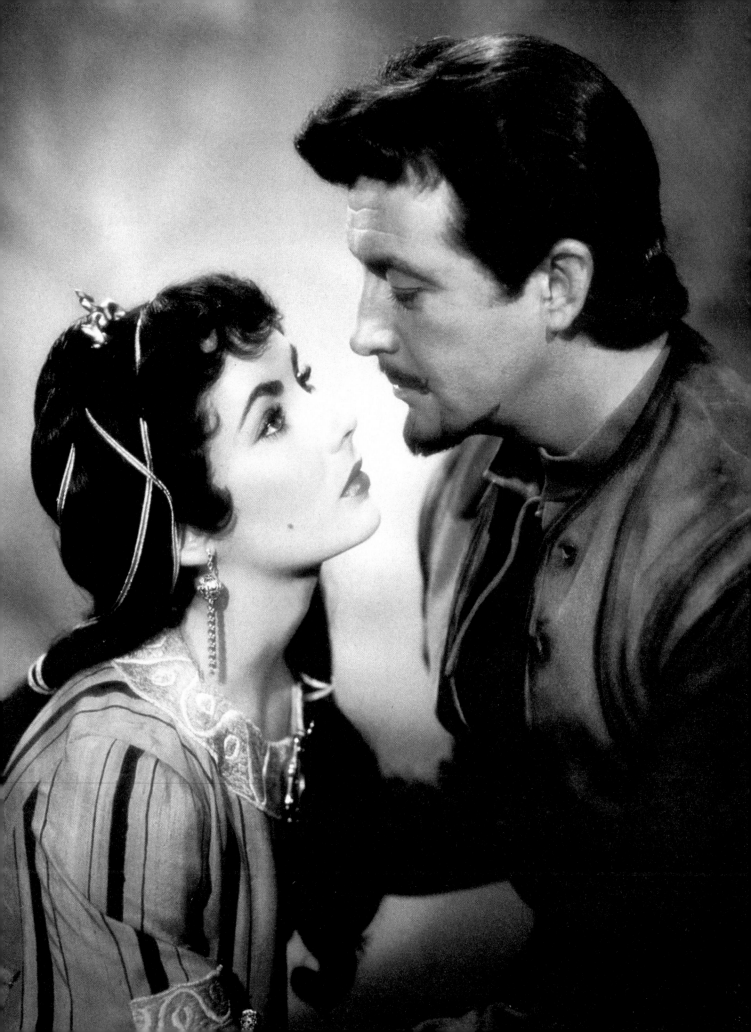

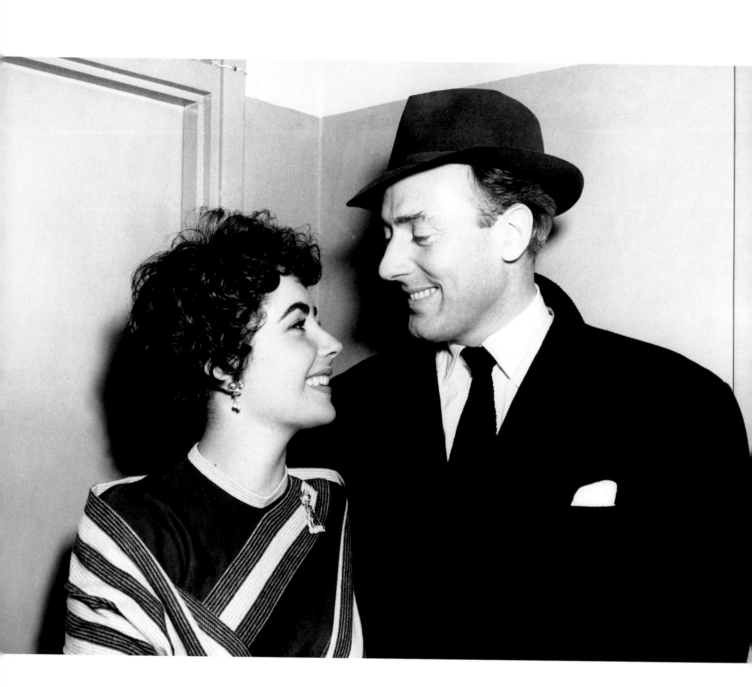

Michael Wilding

..

❉ It was in London, where Taylor was filming *Ivanhoe*, that Taylor met Michael Wilding, a British actor who was filming another movie, *Trent's Last Case*, on the same lot.

Though married, Wilding was known to be a notorious playboy. Despite being almost 20 years her senior, Taylor became enamored with him. She was bound and determined to land him. The effort paid off. He was ultimately divorced and followed Taylor back to California. In February 1952 the couple wed.

Elizabeth saw in Michael a strong, virile partner, one with whom she could start a family. In 1953 the couple had a son, Michael Howard (whom Elizabeth had named in honor of her brother, Howard, who had recently returned from military service in Korea). Their son Christopher Edward followed in 1955.

Unfortunately, the marriage was not meant to last. Wilding's career sputtered in Los Angeles, while his wife's continued to flourish. The two were divorced in 1956.

James Dean

✖ Though the marriage had failed, Elizabeth was left with another important role, that as mother. She was able to keep custody of the two boys, little wonder since their father was near-broke. For the first time in her life, Elizabeth had to take care of someone besides herself. She was 24 years old, with two young boys, and no father to look after them.

It was not just her children who needed looking after, it turned out. She had a nurturing quality that made her smother her loved ones with maternal affection. She felt a particular motherly love for James Dean, whom she met on the set of *Giant* in 1955.

"We had an extraordinary friendship," Taylor wrote in her first memoir. "We would sometimes sit up until three in the morning, and he would tell me about his past, his mother, minister, his loves, and the next day he would just look straight through me as if he'd given away or revealed too much of himself. It would take, after one of these sessions, maybe a couple of days before we'd be back on friendship terms. He was very afraid to give of himself."

Then disaster struck. Just days after wrapping his role in *Giant*, Dean was killed in a car accident. Taylor took the news hard, refusing to continue her work on the movie. It was a tragic precursor to the film's ultimate success.

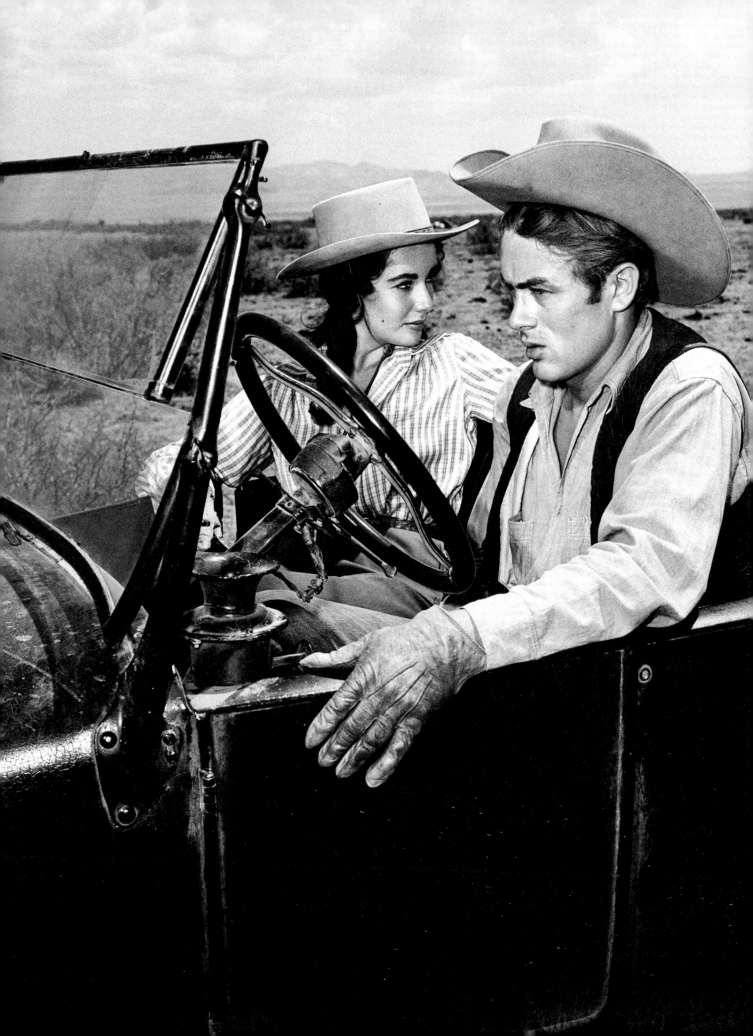

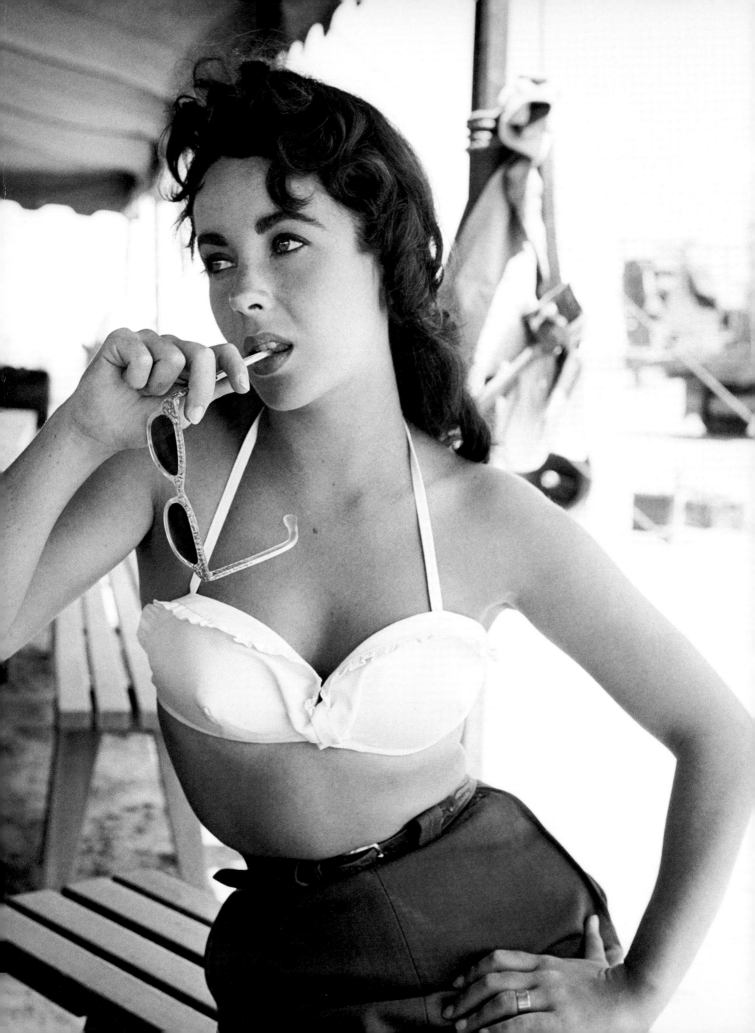

Into the West

⚒ Taylor's reunion with director George Stevens, with whom she had worked on *A Place in the Sun* (and for which Stevens nabbed the Oscar), was a massive undertaking. *Giant* was an epic picture in every sense of the word. The 197-minute opus is the tale of three generations of Texas cattle and oil barons. It is a sweeping film, in which Elizabeth attacks the role with full force, playing cattle baroness Leslie Benedict from her teenage years as a bright-eyed Southern belle, to her last days as a grandmother and matriarch of the Benedict empire.

The film was a huge gamble for Warner's, which had dealt to get Taylor as the female lead. The studio had sunk $5.7 million into the production—no laughing matter at the time—and the filming was marred with difficulties, including the loss of one of its principal stars near the end of completion. Taylor, now a formidable movie star, clashed with Stevens during the filming.

Both Hudson and Dean received Best Actor Oscar nods for their performances, as did Mercedes McCambridge as Supporting Actress. Elizabeth was shut out once again. She was bringing in moviegoers, her beauty was undisputed, but the validation of the Academy voters seemed ever-elusive.

"No one could equal Elizabeth's beauty and sexuality."

DEBBIE REYNOLDS

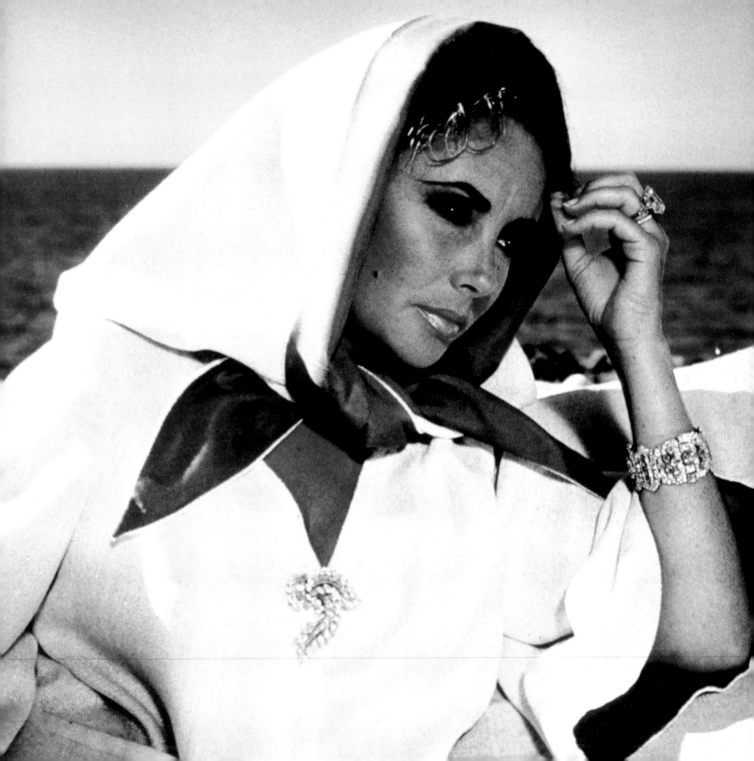

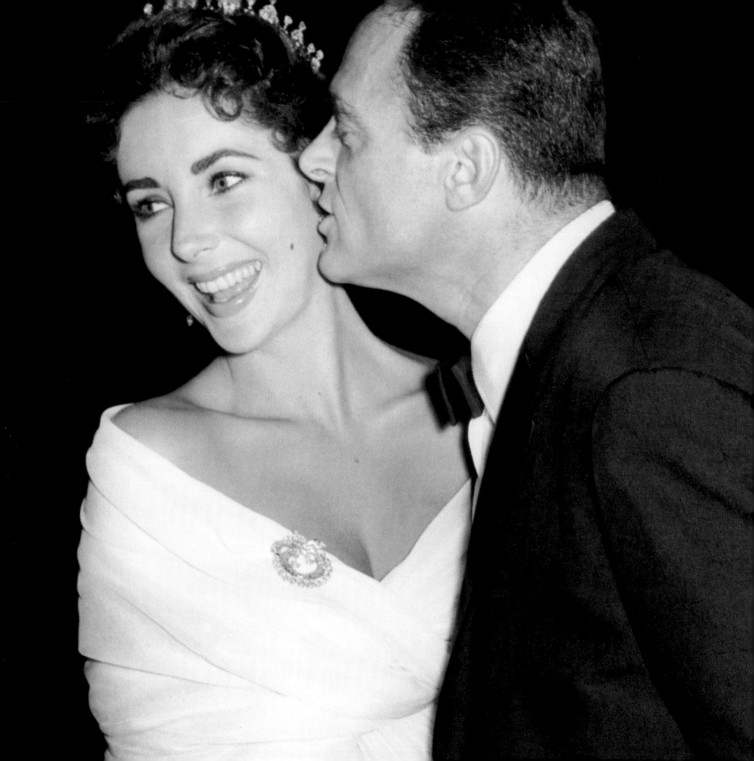

Mike Todd

※ Mike Todd was known as a wunderkind in Hollywood circles, having recently wrapped the ambitious and wildly over-the-top adventure *Around the World in 80 Days*. The film featured a huge cast of Hollywood stars, including Frank Sinatra, Marlene Dietrich, Peter Lorre, Buster Keaton, David Niven, and even playwright Noel Coward. It was an impressive assemblage of talent in one picture. The bigger feat was that Todd was able to convince the stars to do the movie for scale (the minimum working wage for actors in SAG).

Taylor had announced her split from Wilding the very day that Todd called on her. He made no bones about the fact that he was infatuated—no, *in love*—with the star. He simply had to have her. He proceeded to make his case as a husband. It was absurd, but his brashness made an impression on the actress.

"If this is what getting swept off your feet was like," she said years later, "well, I must admit, as much of a brute as I thought he was, I was still quite flattered."

Todd had a garrulous personality and seemed larger than life to all who met him. He was a hopeless romantic. He was also an extravagant gift-giver, bestowing furs, jewelry, and other luxurious gifts on her. There were no two ways about it. Elizabeth was swept off her feet.

"Every woman should have a Mike Todd in her life," she wrote in her second autobiography, *Elizabeth Takes Off*. "My self-esteem, my image, everything soared under his exuberant, loving care."

The couple married on February 2, 1957. It was the third marriage for both.

An Affair to Remember

She was right about Todd's influence. Under his loving care, her career continued to flourish. She started work on another epic, 1957's *Raintree County*, a Civil War–era drama that the studio hoped would mirror the success of 1939's *Gone with the Wind*.

The movie didn't make quite the splash of its predecessor, but it did earn Taylor her elusive first Oscar nomination. Things were looking up.

Things were looking up for Todd, too. He was named Showman of the Year by the Friars Club. Taylor, bedridden with bronchitis, did not make the trip with him to New York.

Elizabeth always had an ominous feeling when she and Todd parted company, and that day was no exception. "I'm afraid that something is going to happen because I'm too happy," she would say.

Mike boarded his private jet, *The Lucky Liz*, en route to the celebration. But he never made it to New York. Authorities in Albuquerque, New Mexico—where Todd's plane was scheduled to refuel—reported the plane crash. There were no survivors.

It was cruel fate that had ended her happy marriage all too soon. Alone again, and with infant Elizabeth now without a father, it was time for her to pick up the pieces and move on once more.

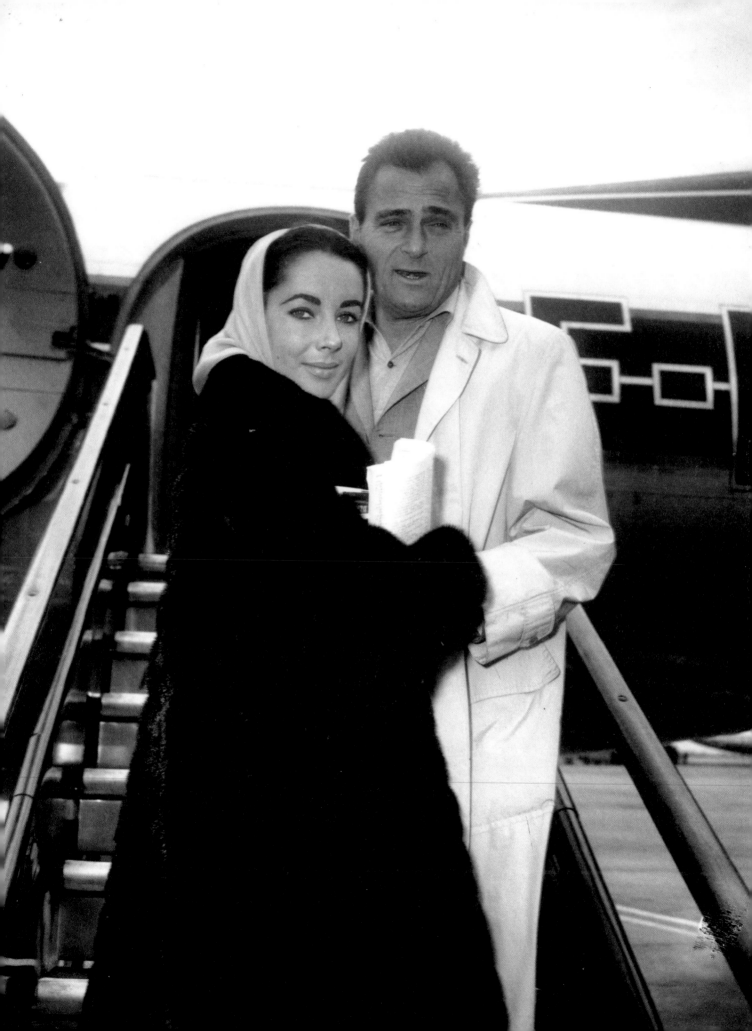

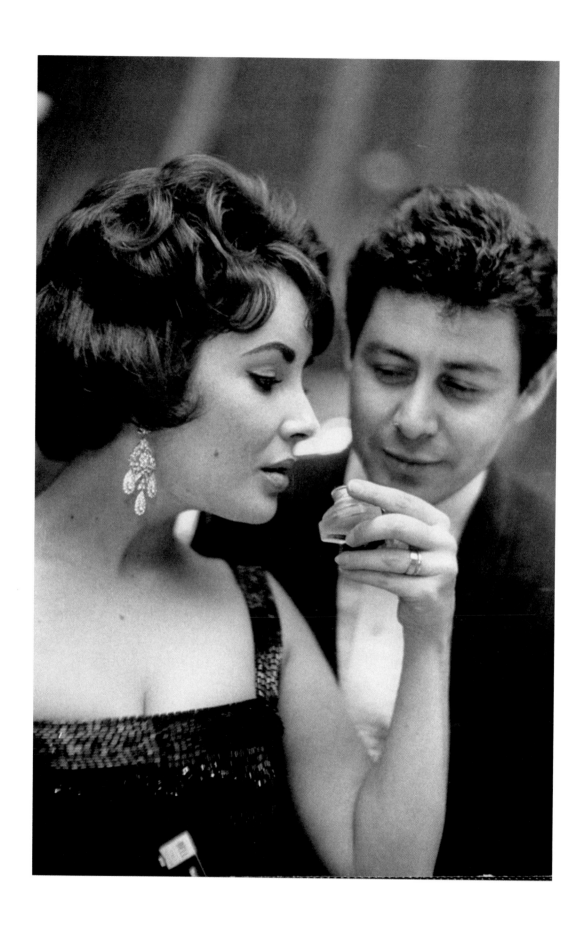

Eddie Fisher

✳ Elizabeth walked around in a daze in the days following Todd's death. His death had struck the Hollywood community hard, as well. None felt it more, perhaps, than Eddie Fisher, who had been Todd's acolyte and close friend. In fact, the Todds and Fishers—Eddie and his wife, Debbie Reynolds—had been a close-knit foursome, often socializing together. It was Eddie and Debbie who helped Elizabeth make it in the wake of Todd's death, even watching after her children while she grieved.

"After Mike died, I went crazy, but Liz went crazier," Fisher once said. He tried to help cheer Elizabeth, regaling her with stories of some of Mike's antics in brighter days. Both missed him terribly.

"The turning point occurred in the summer of 1958," Fisher said. "[Debbie] had invited Elizabeth to join us, knowing how much we both missed Mike and needed each other's consolation.... I stared at Elizabeth and she stared at me—our eyes locked in an embrace and I knew I had fallen in love." The die was cast.

After carrying on a not-so-discreet affair for several months, Fisher and Reynolds separated. He and Taylor were married in the spring of 1959.

Maggie the Cat

So it was that in the midst of personal upheaval, Taylor was again triumphant in her career. Taylor had signed on to play the role of Maggie Pollitt, a seductive temptress, in *Cat on a Hot Tin Roof*, a much-anticipated adaptation of Tennessee Williams' celebrated play. Todd was against Taylor taking the role, fearing nobody would believe that lead character could refuse the advances of such a beautiful woman.

It was just a few weeks into filming when Todd's plane crashed in New Mexico. The accident was a huge blow to the production. Between that tragedy, and more drama unfolding behind the scenes, the filming was headed off the rails. To make matters worse, Tennessee Williams himself derided the production after the studio downplayed the play's homosexual themes.

In spite of the controversy, the movie was successful. And, perhaps to Todd's prediction, there is undeniable screen chemistry between Paul Newman and Taylor. Newman recalled working with Taylor, describing her "a functioning voluptuary...a courageous survivor, a helluva actress and someone I am extremely proud to know."

Taylor was awarded her second Oscar nomination for the performance. Although she didn't win, the film received six Oscar nominations and took home two statuettes. It remains an enduring classic.

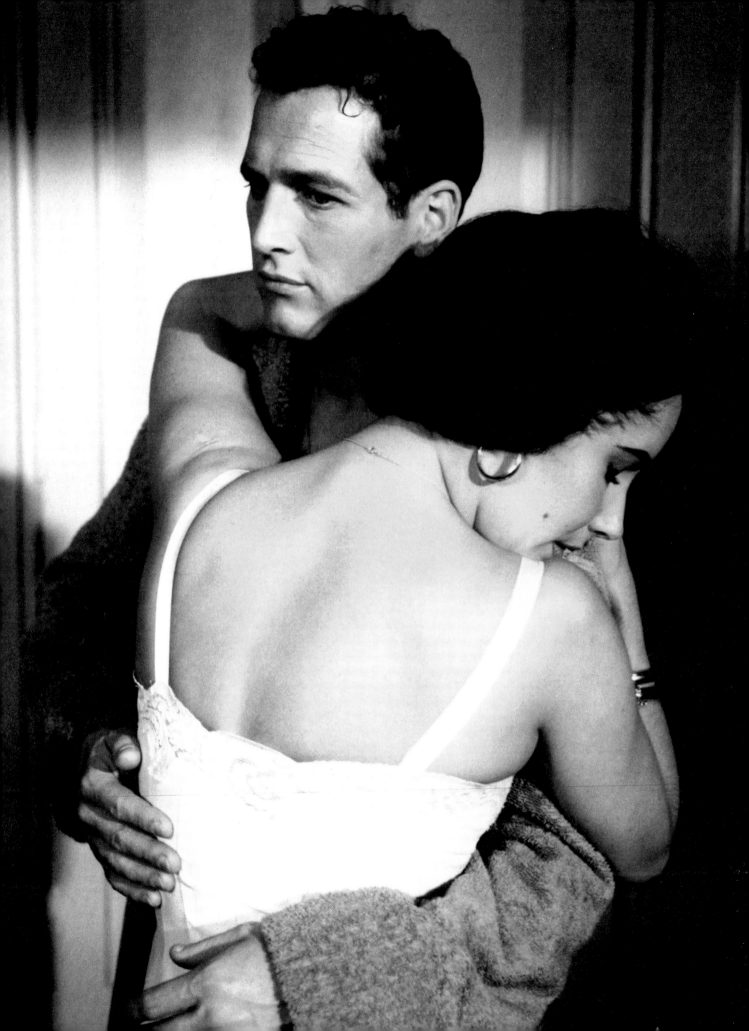

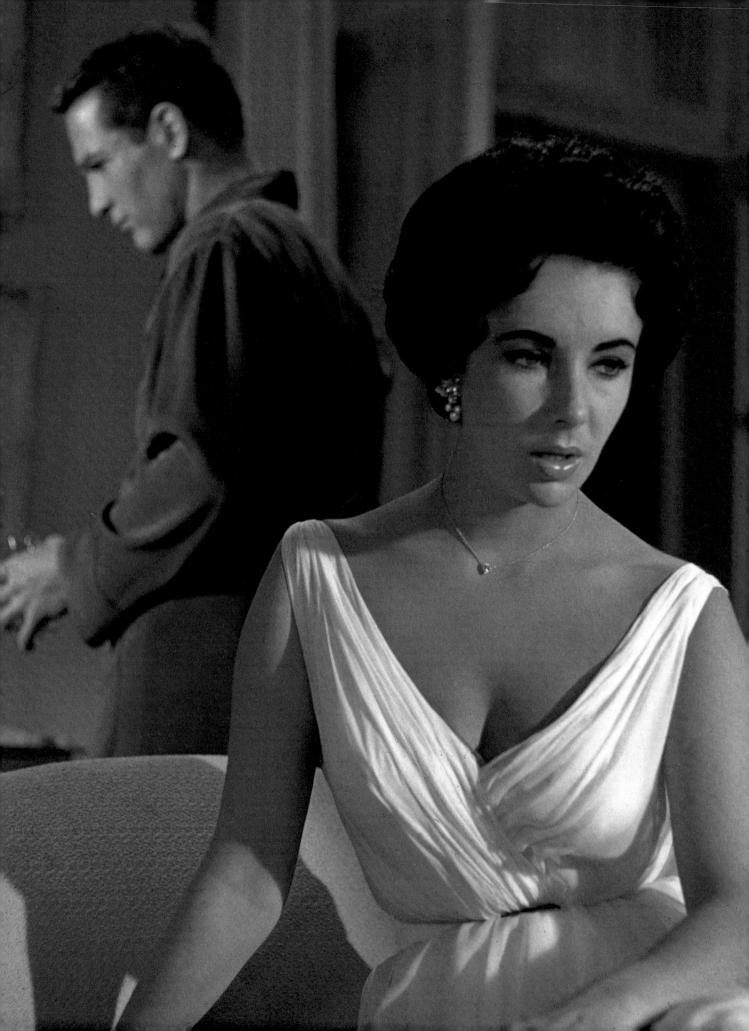

"Her sunny looks…often led the critics to overlook her powerful performances and underrate her acting ability, but she has won over her detractors with tenacity and dedication to her craft. She was always striving to push herself to the limit. Revisiting her work is revelatory. Every time you watch her films you discover something new."

PAUL NEWMAN

A Return to Tennessee

✳ If Maggie the Cat was an overtly sexual role, then Catherine Holly was more discreet. Still, the image of Taylor in that white bathing suit remains one of the actress' most iconic looks.

Again from a play by Tennessee Williams, *Suddenly, Last Summer* was a truly subversive film which paired Taylor with her old friend Montgomery Clift and screen legend Katharine Hepburn. The drama centers on Catherine (Taylor), who witnesses the brutal murder of her cousin, Sebastian, at the hands of a violent gang of cannibals. She returns home to break the news, traumatized. As the drama unfolds, Violet Venerable (Hepburn) pushes to have Catherine lobotomized in order to preserve a sanitized account of her son's death. The movie culminates in a monologue from Catherine, in which she reveals the truth: Sebastian was a homosexual.

It is by all counts an unlikely Hollywood movie. (*Variety* called it "possibly the most bizarre film ever made.") Taylor attacked her role with gusto, and delivers a restrained and convincing portrayal of a woman on the edge of madness. The performance earned her yet another Oscar nomination, her third-consecutive.

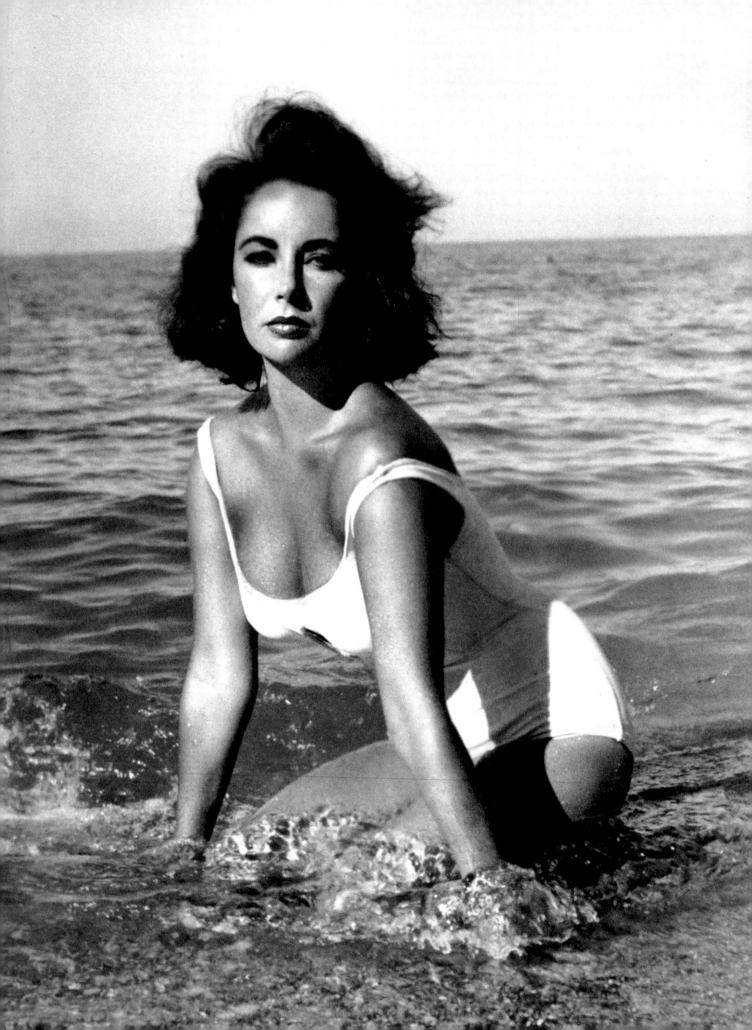

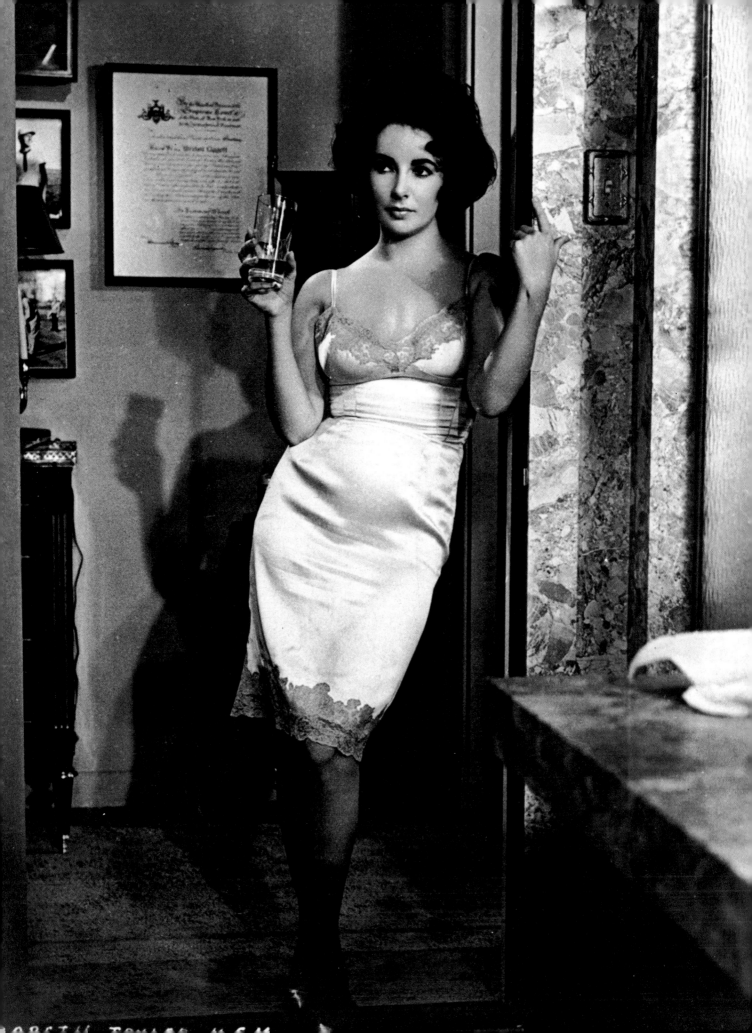

Gloria Wandrous

By all counts, *Butterfield 8* was a picture that Taylor had no interest in making. In fact, she tried several times to get out of the production.

The star had just signed on for 20th Century Fox's epic *Cleopatra*, and promised a record-breaking $1 million for the role. She became the first actor—male or female—to command the sum. Much to the star's chagrin, she had one more film to make under contract with MGM—to the tune of a measly $125,000—and even the most powerful woman in Hollywood couldn't get out of that obligation. Taylor, upset that the studio forced her hand, was bound and determined to make the filming difficult for the powers-that-be.

The film, an adaptation of the John O'Hara novel, follows the exploits of Gloria Wandrous, a woman-about-town and call girl in New York City. As J. Randy Taraborrelli writes in *Elizabeth*, "the script was rife with illicit sex and rampant boozing; it was, arguably, the perfect Elizabeth Taylor vehicle."

And perhaps because of it, Taylor turned in a winning performance in spite of herself. Her Gloria was a tour de force. It was further proof that the actress could hold her own in front of the camera, regardless of what was happening in the real world.

Oscar Comes Calling

On March 4, 1961, Elizabeth was in London with her family, getting set to begin production on *Cleopatra*. She collapsed in her hotel room and was found suffocating, her face had turned blue. She was rushed to the hospital, where she underwent an emergency tracheotomy. She was desperately ill; doctors feared the worst.

Truman Capote visited her there in the hospital, recalling later, "She was very lively, though one could see she had gone through a massive ordeal."

She returned to the United States to recuperate, and was honored at a fund-raiser for Cedars-Sinai Hospital. There she addressed the audience on her near-death experience. "Throughout many critical hours in the operating theater, it was as if every nerve, every muscle were being strained to the last ounce of my strength. Gradually and inevitably, that last ounce was drawn, and there was no more breath. I remember I had focused desperately on the hospital light hanging directly above me. It had been something I needed almost fanatically to continue to see, the vision of life itself. Slowly, it faded and dimmed, like a well-done theatrical effect to blackness. I died." The impact on the audience was immediate and intense.

With public sympathy on her side, an Oscar win for her work in *Butterfield 8* seemed more certain than ever. On April 17, just a month after the actress' dramatic brush with mortality, she won the Academy Award.

"Hell, even I voted for her," Debbie Reynolds remarked. So with Reynolds' ex-husband Eddie Fisher on her arm, Taylor accepted the coveted prize for the first time in her career.

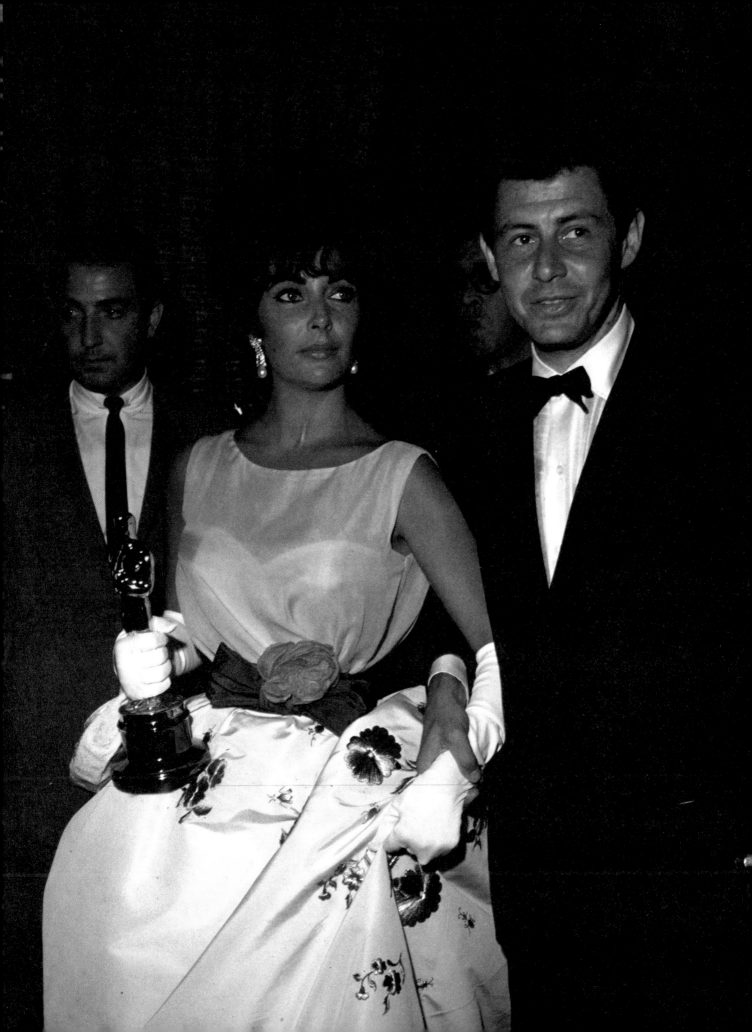

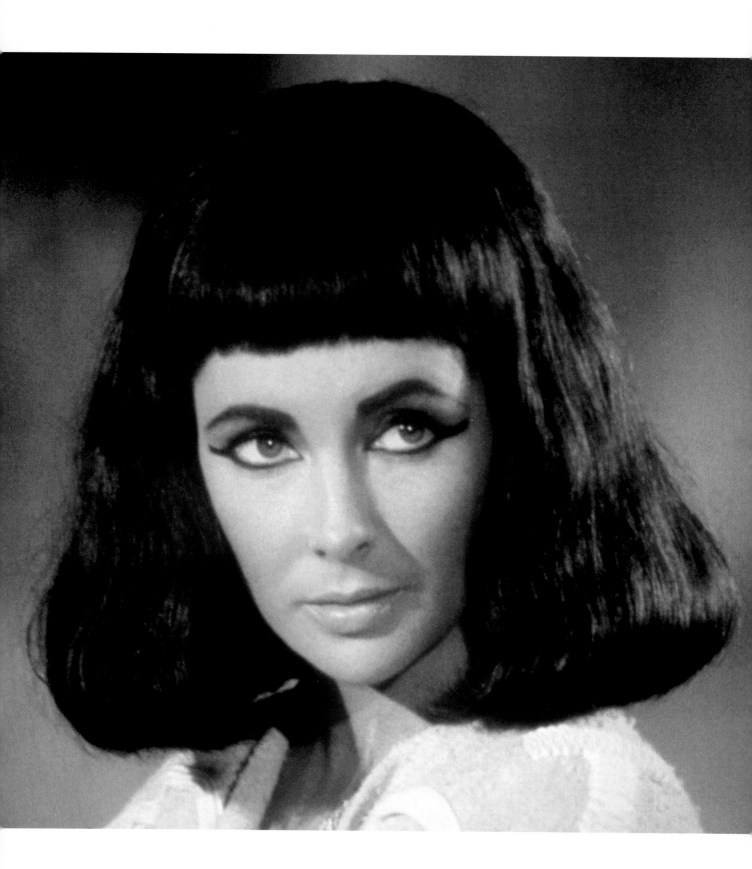

The Million-Dollar Woman

Delays in the production had already changed the face of *Cleopatra* before shooting ever started. Producer Walter Wanger had fought hard to get Taylor for the production, and the queen still remained. But several of the principal actors were forced to drop out because of other professional commitments. With Taylor's health flagging, the production was in dire straits.

But the moment that Elizabeth Taylor first walked on the set in January 1961, shrugged out of her mink coat, and turned herself over to makeup artists, everyone knew they were in for something special.

In many ways, Taylor was like the Egyptian queen she portrayed: intelligent, fierce, persuasive, but also selfish and uncompromising.

Shakespeare, describing the queen in his play *Antony and Cleopatra,* wrote, "Age cannot wither her, nor custom stale her infinite variety; other women cloy the appetites they feed, but she makes hungry where most she satisfies." It was just as apt a description of Taylor.

Another Child

✳ To Elizabeth, it was becoming increasingly evident that there was something missing in her relationship with Eddie. They had united over their shared grief, but she needed more. Something had to give. She began to develop a powerful longing for another child, but could no longer conceive naturally. She was convinced that there was a child who did not have the means to survive, someone who she could nurture given her own circumstances. She appealed to their friend Maria Schell (sister of actor Maximilian) to help them find a suitable child to adopt.

Schell found a child born in a small town in Germany who was premature and would need months of hospital care in order to survive. The family was impoverished and unable to pay for the care that the child so desperately needed. It was not a decision that the parents made easily, but in the end it was the best one for the baby. Taylor was overjoyed. She wrote the parents, saying "Not only do I have the money, I also have the love to give, and I so want to give it."

The adoption was finalized in January 1962. The little girl would be called Maria, after Schell, who was instrumental in uniting the family.

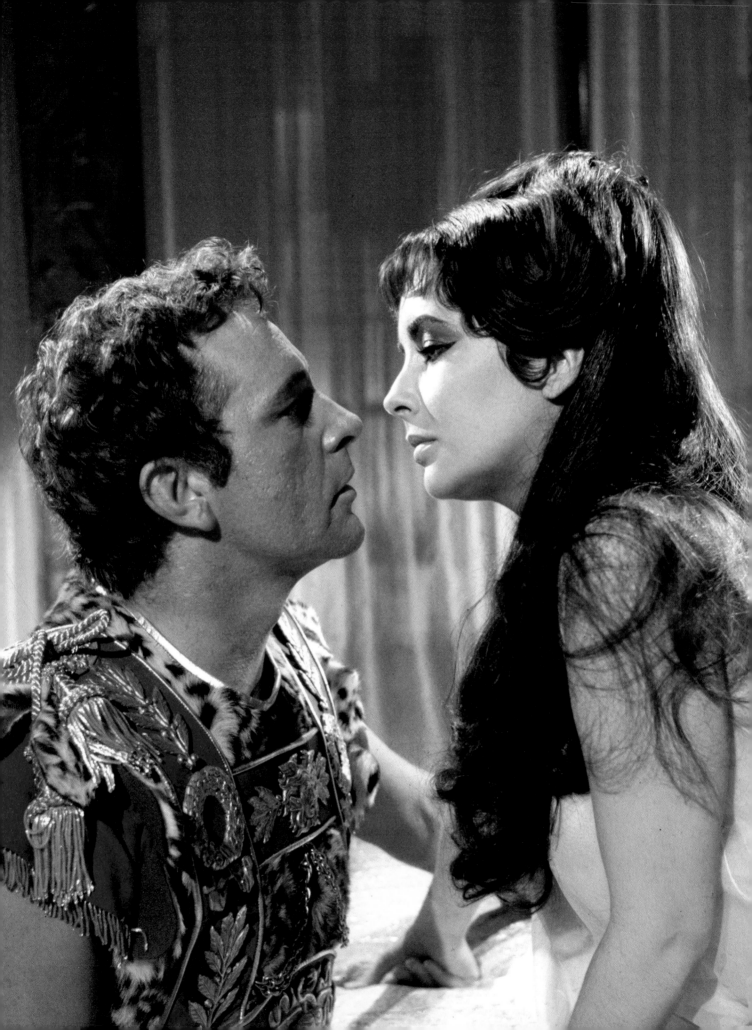

Richard Burton

⚹ As the legend goes, Richard Burton approached his famous co-star on the first day of shooting. According to onlookers, he marched right up to her, leaned into her ear, and said, softly, "You're much too fat, love. But I admit, you have a pretty little face." It was the first time she would lay eyes on Richard Burton, the Welsh actor who was known for his booming voice as well as his unfailing incorrigibility. The insult might have infuriated the actress, but there was something to his audacity that penetrated her defensive veneer; she had to laugh.

Though she was married, there was something about her leading man that intrigued her. Their connection was magnetic, instantaneous, and overwhelming. The two began spending time together on set, at lunch each day, and at dinner each night. They had not even shared a scene together, and were not scheduled to do so until almost four months into principal photography. By the time those scenes finally came, the two were unmistakably entwined.

Their real-life emotions echoed the dialogue in the scene. Cleopatra whispers her desperate entreaty to Mark Antony: "To have waited so long, to know so suddenly. Without you, this is not a world I want to live in."

Antony, responding, "Everything that I want to hold or love or have or be is here with me now."

"That girl has true glamour. If I retired tomorrow, I'd be forgotten in five years, but she would go on forever."

RICHARD BURTON

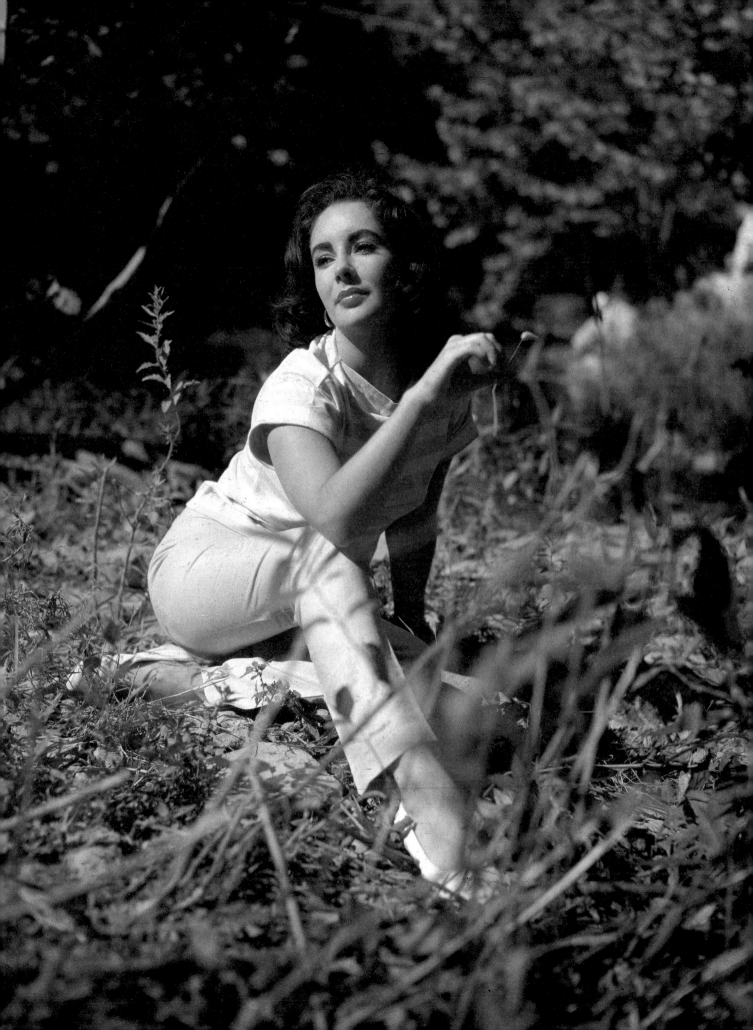

Lizandick

❊ By February 1962 Taylor and Burton had fallen hard for one another. Though both of them were married, the two carried on the affair as if they were free and unencumbered. They went out together, they were affectionate with one another. By that time, there was nothing secret about their relationship.

Fearing blowback from the studio, Mankiewicz spoke with producer Walter Wanger. "I've been sitting on a volcano all alone for too long, and I want to give you some facts you ought to know," he told him. "Liz and Burton are not just *playing* Cleopatra and Antony."

The press soon caught wind of the story, splashing headlines on both sides of the Atlantic. News about the actress, already with a reputation for romantic indecision, was hotly anticipated. They anointed the new couple "Lizandick." Fisher was humiliated.

And so, the tempestuous relationship between Elizabeth and Richard began; it would go on for decades.

"From those first moments in Rome we were always madly and powerfully in love. We had more time but not enough."

ELIZABETH TAYLOR

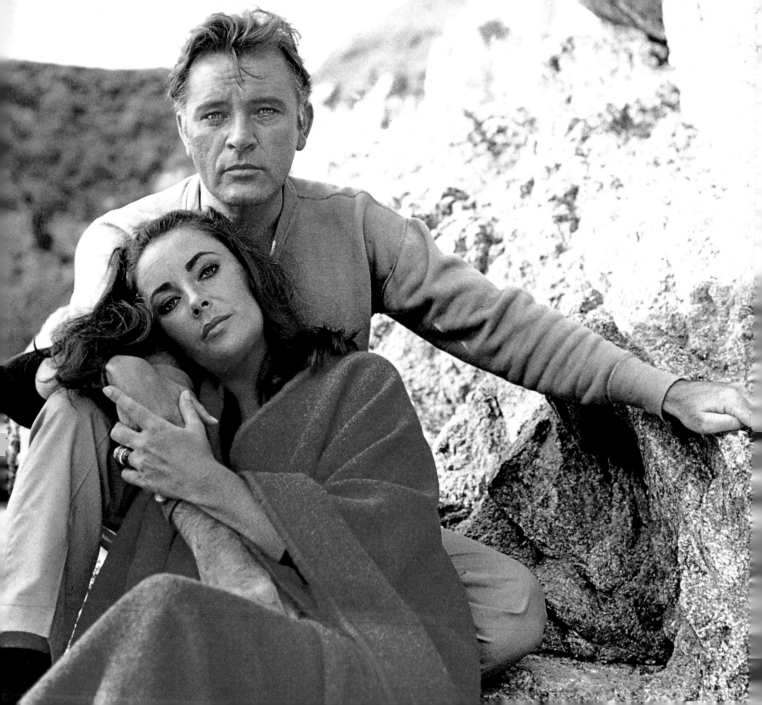

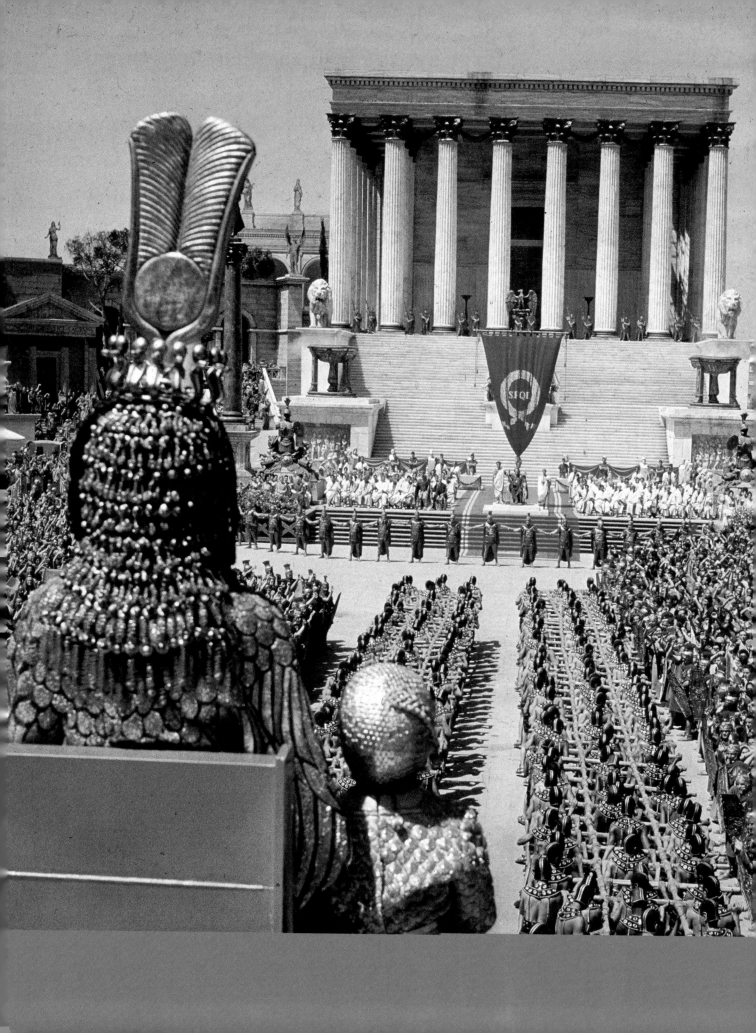

Queen Liz

�֎ The tabloids had a hold on the Burton-Taylor romance. The entire affair was spectacle. It was a love story that stood starkly in the face of the times. And *Cleopatra* was being filmed in Rome, the locus of the Catholic Church. A romantic entanglement between two married co-stars simply wouldn't do.

The Italian papers blasted the couple for their lack of morality. Pope John XXIII even commented, "We like to call Rome the Holy City. God forbid it become a city of perversion."

But the times, they were a changin'. And while Burton and Taylor suffered widespread criticism in the press, they went on loving one another. In their minds, it was impossible not to.

There is a scene in *Cleopatra* in which she is carried on the Sphinx by a galley of slaves to be presented to her public. Surrounded by pure pageantry—horses, chariots, dancers, and musicians—she is greeted with the utmost adulation. *"Cleopatra! Cleopatra! Cleopatra! Cleopatra!"* they shouted. But as the scene went on, the chanting started to change. *"Liz! Liz! Liz! Liz!"* the extras roared.

It was moment a validation for the actress who had been all but crucified by the local press. Public opinion was indeed on their side.

Cleopatra Arrives

�֍ The movie was bombastic from its very beginning. It began with a series of fits and starts. It continued with the high-profile romance of its two principals, two extremely combative personalities who did nothing to make things easier on the production. Budgets soared. Schedules dragged on. People protested. But for all the outsized drama, the movie premiered not with a bang but a whimper. For all the spectacle, it was simply viewed as something of a dud. A very expensive dud at that.

Taylor reaped some of the worst reviews of her career for the performance, which was largely derided as "dull" and "wooden."

As Taylor wrote in her 1965 memoir, "I was involved with *Cleopatra* for five years on and off and surely that film must be the most bizarre piece of entertainment ever to be perpetrated—the circumstances, the people involved, the money spent. Everything was such a nightmare that it is difficult even to know where to start. It had some curious effect on just about every person who worked on it."

Still, "the most expensive movie ever made" didn't end up being moviedom's most expensive mistake. The $50 million debacle (its original budget was $2 million) went on to earn back its cost and then some; the film is still among the highest grossing movies of all time.

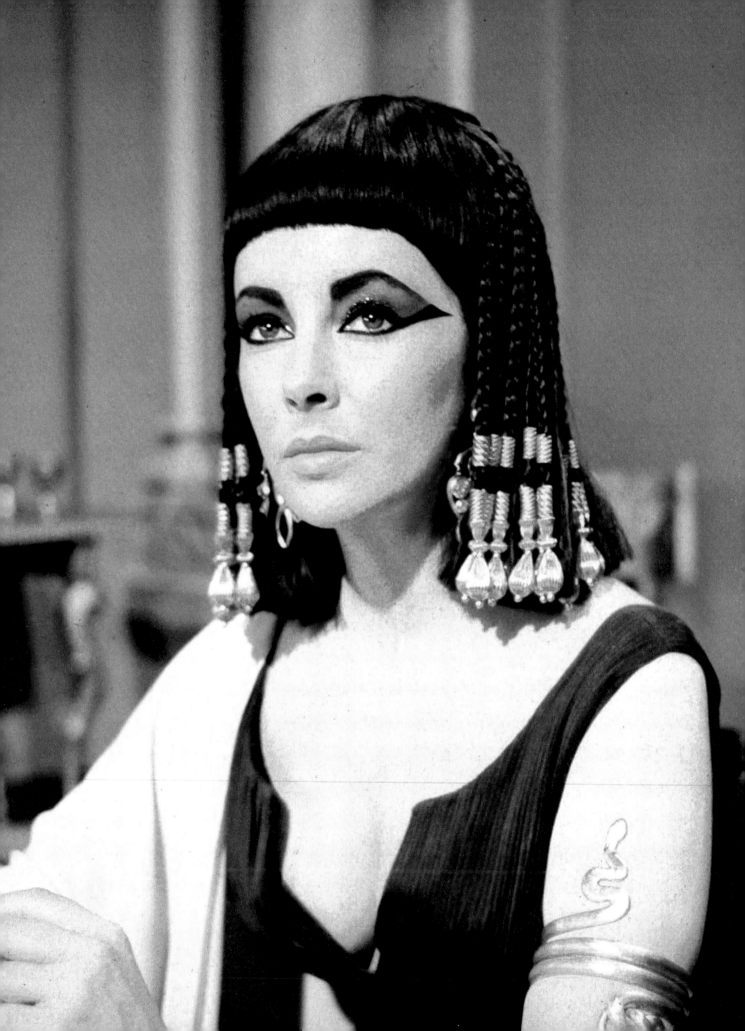

Love South of the Border

..

✳ After the madness of *Cleopatra* subsided, the couple retreated to Mexico. Richard was slated to film an adaptation of Tennessee Williams' sinister *Night of the Iguana*. Elizabeth was more than happy to follow. After the harsh glare of the paparazzi, the remote location would be a welcome change.

The two of them were ensconced in a palatial 22,000-square-foot mansion in Puerta Vallarta called Casa Kimberly. With 10 bedrooms, 11 bathrooms, and three kitchens, it was posh, to say the least. More importantly, it was a retreat.

You could see in their faces that a sort of serenity had overtaken them. They were blissfully, unabashedly happy with one another. Both actors have acknowledged that it was in Mexico that their love was able to really take root.

It was in Mexico that Richard "began to fall for her in a way that he hadn't before, and she for him," Burton's brother Graham Jenkins recalled. "I think it was at Casa Kimberly that their true love was born. Before that it was just a tumultuous romance.... Now they were one."

Mad Love

Richard and Elizabeth were by all counts together, but there was one problem: they were both still married. Elizabeth had already set into motion her divorce with Eddie, but Richard was bullish.

"You mustn't use sex alone as a lever, as a kind of moral, intellectual, psychic crush to get away from your wife," he told one reporter. "I can't say to her, 'I'm terribly sorry but I...simply have to run off with this infinitely fascinating girl.'"

The comments had to sting Elizabeth, who was ready to move on with her life—and take Richard with her. Finally, in the spring of 1963, he made his choice. He would leave his wife and family to be with the woman he loved.

Nothing was ever easy with Liz and Dick. They were often observed having it out in public. They would yell, they would claw at each other, and they would fall in love all over again. It was their mutual flair for the dramatic that seemed the glue between them. And it was this passionate loving that made them the fascination of people everywhere.

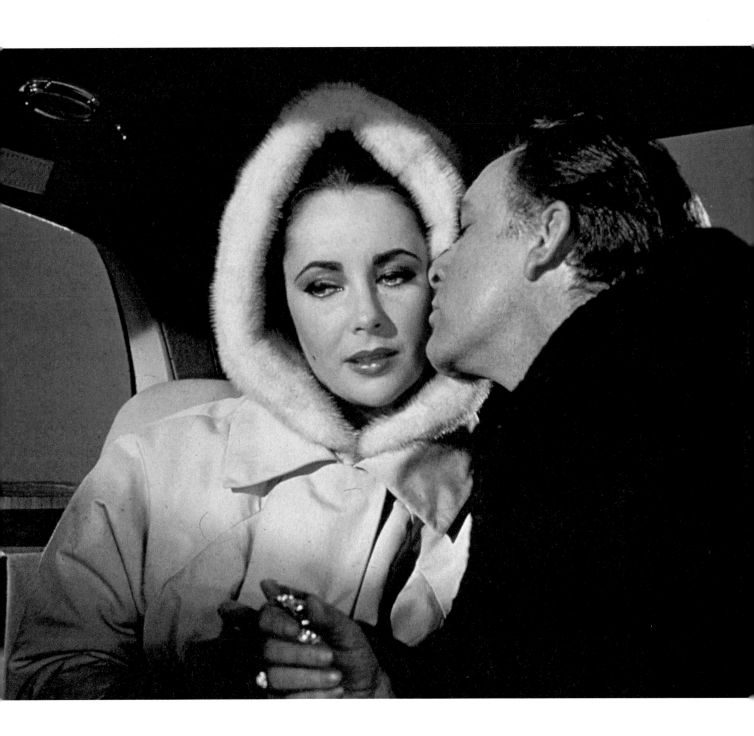

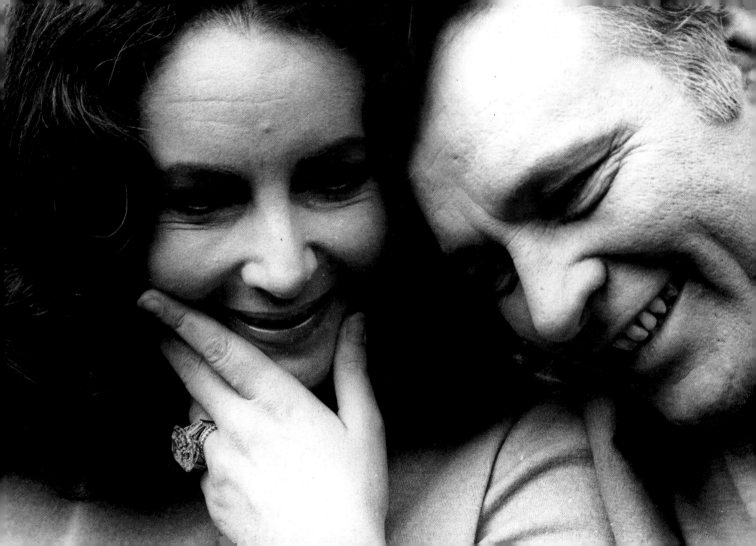

"I fell in love at once. She was like a mirage of beauty of the ages, irresistible, like the pull of gravity. She has everything I want in a woman. She is quite unlike any woman I have ever known…. She will be my greatest happiness—forever, of course."

RICHARD BURTON

"Always a Bride, Never a Bridesmaid"

✳ By the spring of 1964 Taylor and Burton were both free. And nearly as soon as the ink dried on her divorce with Fisher, Elizabeth was married again. The couple had been together for almost two years, officially or unofficially; the wedding ceremony lasted just 10 minutes.

The bride was the very embodiment of the '60s sexual revolution with which she was identified. Wearing a sunny yellow dress and with floral garlands strewn through her hair, she was a walking flower child.

If the press was skeptical about this most perfect union, it was only because they'd been down the road before. Only 32 years old, this was her fifth trip to the altar. Taylor's longtime friend Oscar Levant quipped of his friend and the union, "Always a bride, never a bridesmaid."

The couple insisted that this time it would be different. And there was something about them that made everyone feel as if it were true.

"I truly believe in my heart that this marriage will last forever," Elizabeth said on her wedding day. In one way or another, it did.

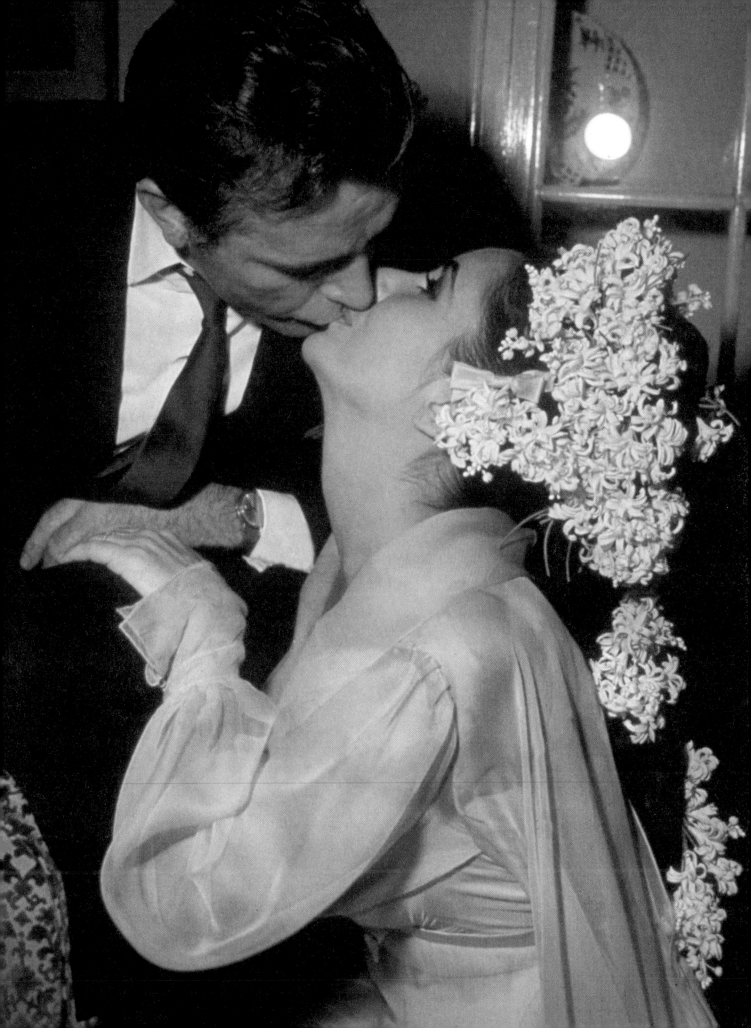

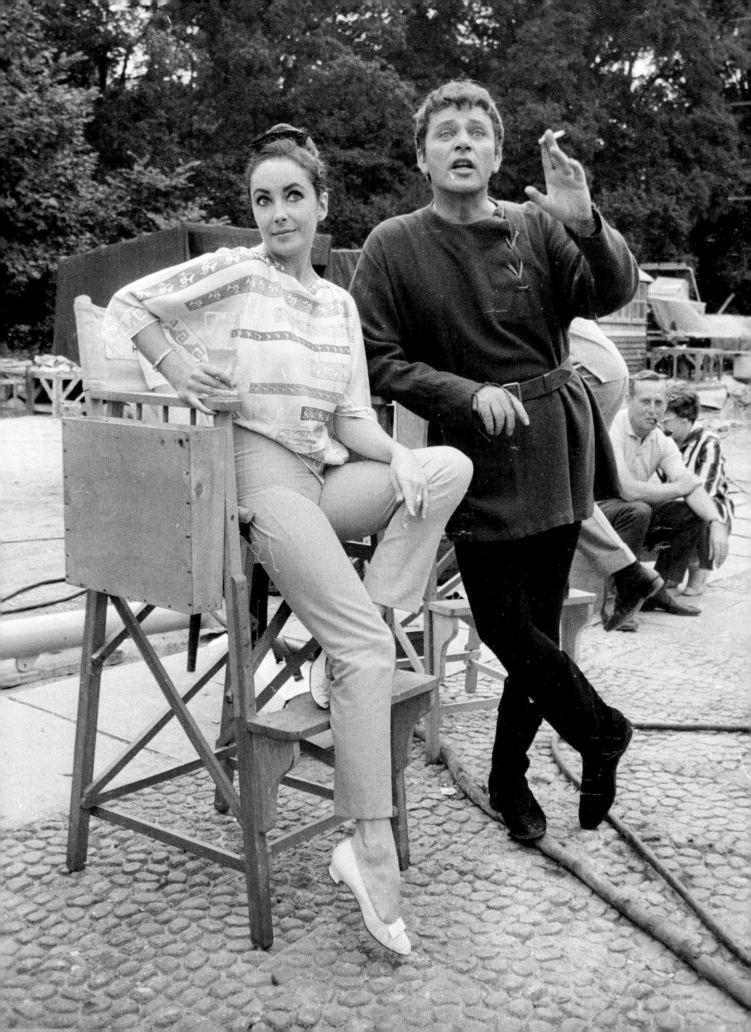

Supporting Richard

✖ The public rejoiced in their marriage, but as actors, they knew that the show must go on. Now official, they set about making a string of movies together. There was the airport melodrama *The V.I.P.s*; the red-hot romance *The Sandpiper*. In all truth, it didn't matter, so long as they were together.

Elizabeth also found herself in a new role: second fiddle. She wanted desperately for her husband to have the validation as an actor that she already felt she had. She encouraged him to take the part of Hamlet in a Toronto production that was headed to Broadway. Richard was a known stage actor and a natural for the part, but his insecurity was showing.

"It's best if you watch from the wings, love," he said. "Soon they'll be selling tickets to see you and not me."

So she watched raptly from backstage as he delivered his performances. She accompanied him on film shoots, even though she didn't have a part of her own to play. It hardly mattered. The couple relished their time with one another.

"It's fine. I'm not interested in making movies right now. I just want to help Richard," she said at the time.

Liz and Dick Become "Afraid"

As content as she may have been to stand on the sidelines, Taylor would eventually have to get back to the grind. Edward Albee's play, *Who's Afraid of Virginia Woolf?* had swept the Tony Awards and was the toast of Broadway. The story centers around a middle-aged couple—George, an associate professor at a small New England college, and Martha, the daughter of the president of the college—who are entertaining a young couple in their home. Over the course of the evening, the cracks in the façade of the marriage start to appear, until the two unravel completely.

The boozy, anger-filled couple George and Martha may have borne some similarity to their real-life counterparts, but most Hollywood insiders thought the casting was a stretch. For one thing, Elizabeth was far too young at 34 to play the forty-something Martha.

Taylor poured herself into her character with reckless abandon, even putting on a fair amount of weight for the role. "She didn't mind looking puffy and haggard, nor did she want to resemble the Fat Lady in the circus," recalled Haskell Wexler, cinematographer on the film. "Extremely conscious of her screen appearance, she constantly reminded me that she wasn't supposed to look good. Then she whispered, 'Well, I'm not supposed to look awful either.'"

The film ended up being a triumph, by far the best picture the couple would make together. It was also a personal victory for Taylor, whose dramatic turn sent shockwaves through Hollywood. She had given everything of herself to that performance, and it was a role completely and utterly devoid of vanity. It is little wonder it is often lauded as the best performance of her career.

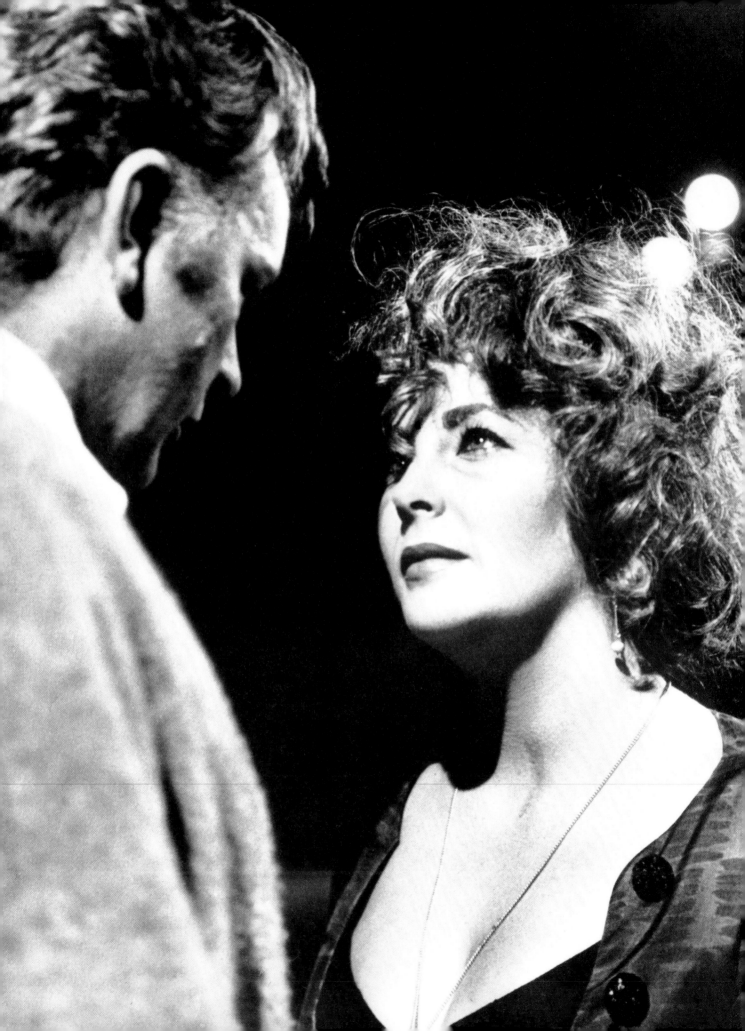

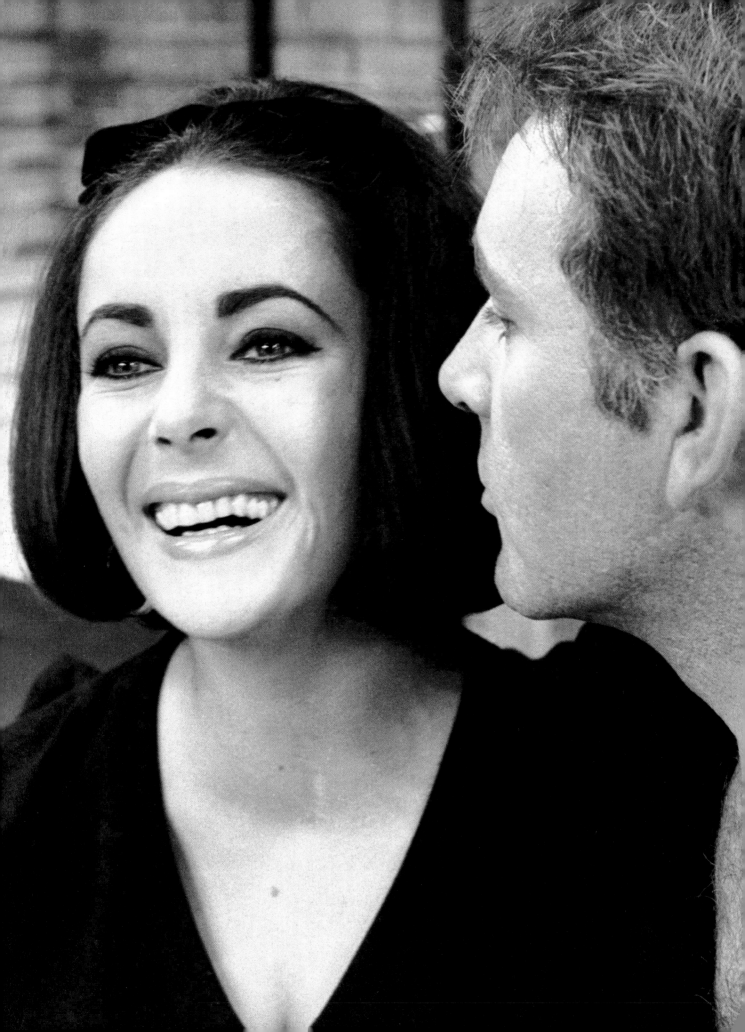

"The shock of Elizabeth was not only her beauty. It was her generosity. Her giant laugh. Her vitality."

DIRECTOR MIKE NICHOLS

Eternal Co-Stars

✳ Despite personal difficulties—Liz's degenerating health, Richard's increasing struggle with alcohol—the late 1960s were a productive time for the Burtons. They were constantly in motion, jumping from project to project, but always together.

The first movie they lined up after *Who's Afraid of Virginia Woolf?* was an adaptation of Shakespeare's *The Taming of the Shrew*. By now, the public was well-acquainted with the couple's real-life histrionics. Imagining them in the roles of Kate and Petruchio was an easy leap to make. In addition, Burton's prowess as a Shakespearean actor was widely acknowledged. With director Franco Zeffirelli at the helm, the picture would be a slam dunk. And indeed, the couple brought their particular brand of love-hate chemistry to the set. Unfortunately, the end result was a disappointment. The pratfalls and chuckles gave the film a ham-handedness that eschewed the appropriate Shakespearean reverence. Critics eviscerated it.

Their next efforts fared no better. *Doctor Faustus* left audiences cold; Haiti-set *The Comedians* fell flat. Luckily, all three turned a profit.

If their creative efforts waned, it was only because the drama was playing out off-screen. And the public wanted more of Liz and Dick. They were, if nothing else, movie stars.

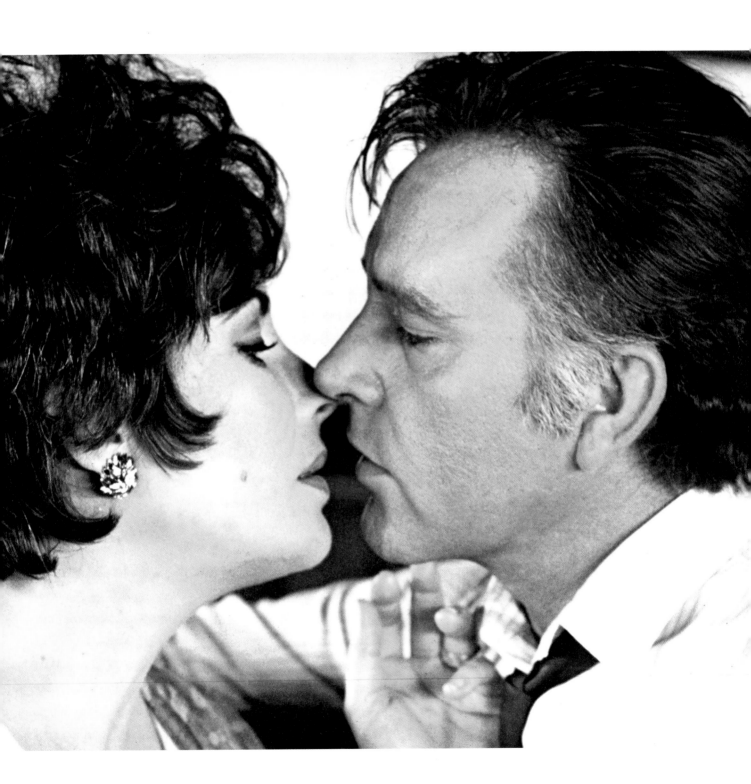

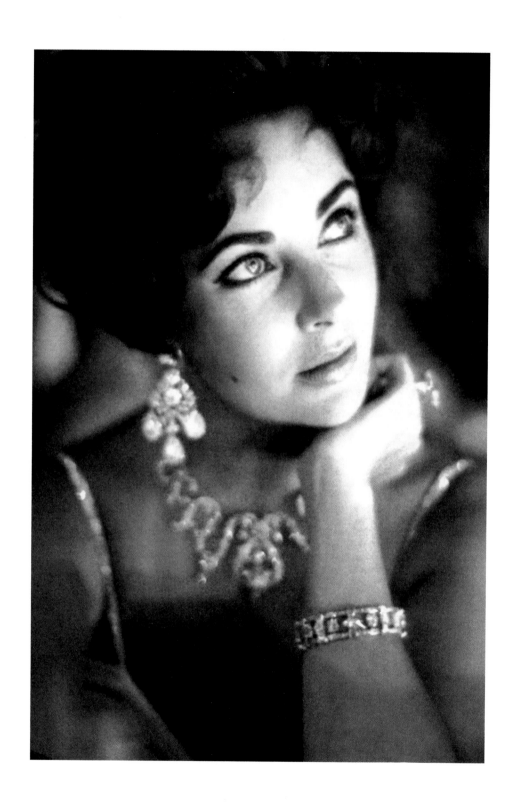

The Lap of Luxury

✳ One of the richest women in Hollywood, Taylor was renowned for her fine taste in jewelry. It was one of her signature trademarks.

Expensive gifts were a mainstay among Taylor's suitors, but no one was more extravagant than Burton. When a whopping 33.19-carat diamond came up for auction in 1968, Burton plunked down over $300,000 for the prize. It was an unrivalled gem, enormous in size. Taylor jokingly called it her "ice cube."

It was just one of many beautiful tokens that Burton would present to Taylor over the course of their relationship.

He also famously purchased a whopping 69-carat diamond. The Cartier Diamond or, as it came to be known, the Taylor-Burton Diamond, was an eye-popping stone. Ultimately Elizabeth had it made into a necklace; it was so big that she couldn't wear it as a ring.

There were other such bestowals along the way, from the gorgeous (and also giant) La Peregrina pearl to an antique Persian necklace. All told, the Burtons had over $5 million in jewels.

But then they didn't all come from Burton. It was Taylor's lifelong love of jewelry that grew her enormous collection. Later, she would establish House of Taylor, a luxury jewelry company of her own.

Another Oscar

�֍ *Who's Afraid of Virginia Woolf?* became a huge success with critics. And by the time Oscar nominations rolled around, the validation was complete. The movie was nominated for an award in every category in which it was eligible (13 out of 13), the only film in Oscar history to accomplish the feat. Burton and Taylor were both singled out for their performances.

It was the fifth nomination for both actors. Taylor had previously been recognized for *Raintree County*; *Cat on a Hot Tin Roof*; and *Suddenly, Last Summer*, and had won for *Butterfield 8*. Burton was a four-time loser, though recognized for *My Cousin Rachel*, *The Robe*, *Becket*, and *The Spy Who Came in from the Cold*.

The *Woolf* nomination was a coup for its stars, but Burton couldn't face losing again. Elizabeth had planned to attend the ceremony herself, before Richard slipped into a violent depression. Torn between her duty as an actress ("Don't burn the bridges you have built," warned studio boss Jack Warner) and her spousal obligations, she remained in London with her husband.

Elizabeth did win the Oscar, as fate would have it. Actress Anne Bancroft accepted on her behalf. Burton lost yet again.

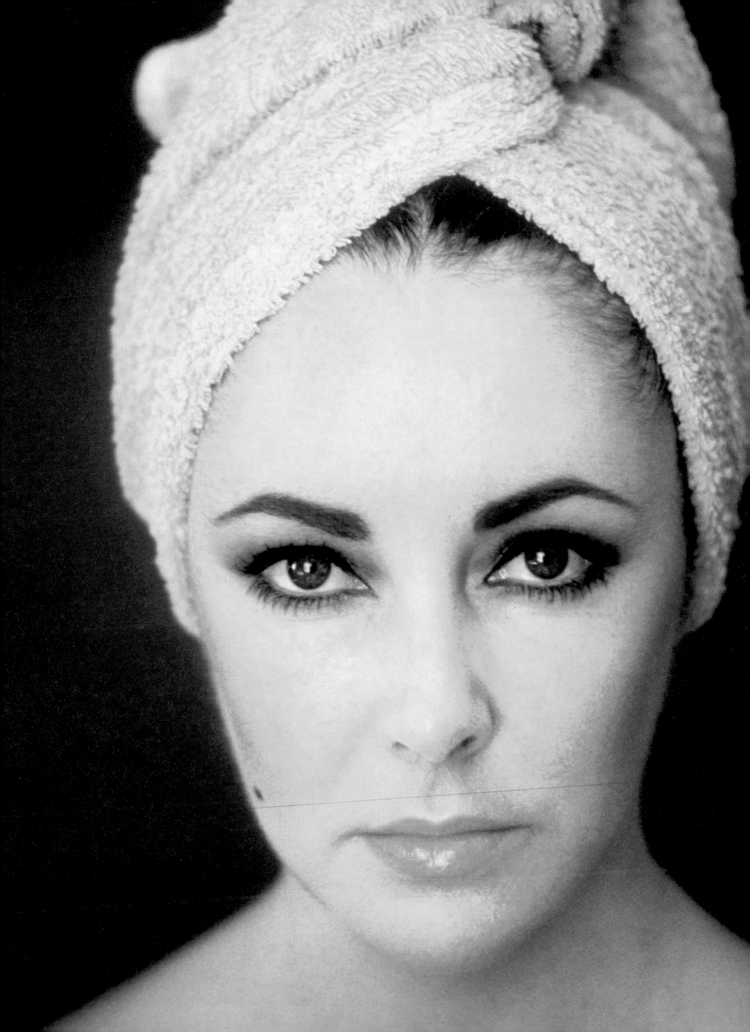

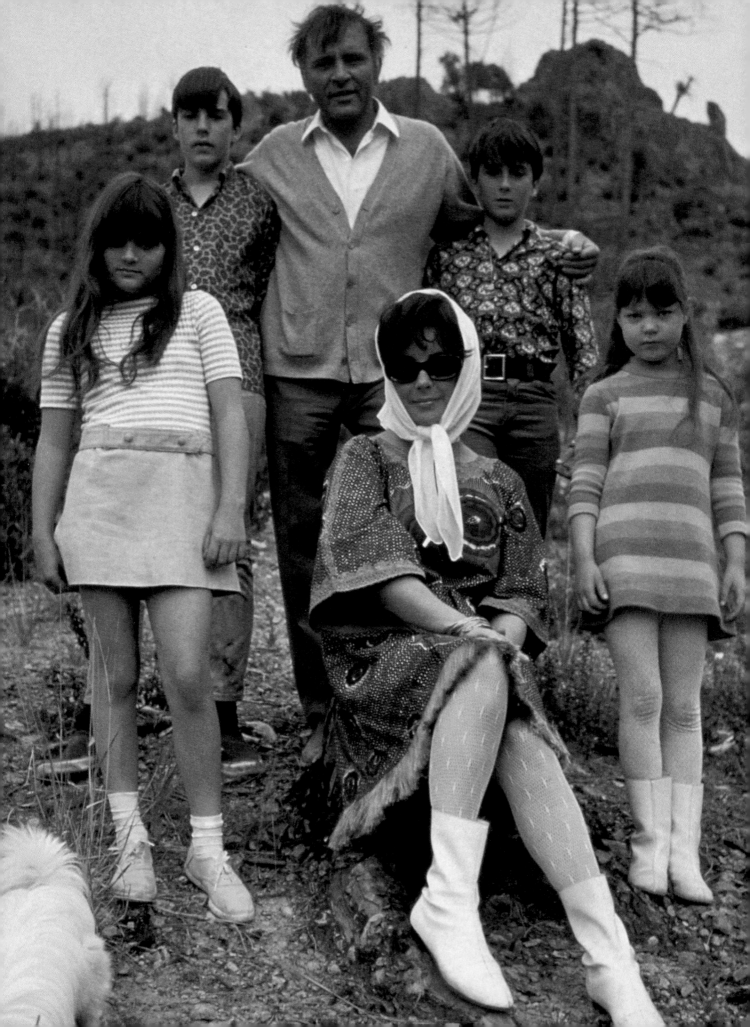

The Burton Family

Through the lens of celebrity, it is often easy to forget that the Burtons were more than Lizandick. They were a family. Elizabeth had four children of her own: Michael, Christopher, Liza, and Maria; Burton had two daughters: Kate and Jessica. Both Michael and Christopher lived with their dad in California, and Jessica was still in a sanitarium at the time. Kate lived with her mother, though she maintained a close relationship with her dad. The rest of the brood lived with Elizabeth and Richard, traveling with them from city to city and shoot to shoot.

It was an unconventional childhood, to be sure. Perhaps the parents, with all their bluster, were not the most available. But there is no question that there was love in that house for them. Maria, Taylor's adopted daughter (at the time with Fisher), became Maria Burton. Richard was the only father she would know. Liza, too, would come to be particularly close with him, and was often Richard's partner in crime, pulling pranks on Mother.

From a distance, it almost seemed normal. But the bottom was about to fall out.

Divorce, Then Reconciliation

The following years proved to be a tumultuous time for the Burtons. Richard was sinking deeper into depression—and into the bottle. The couple, starting work on a made-for-television movie called *Divorce His, Divorce Hers*. They were yet again playing out their personal drama on the screen.

On Independence Day 1973, she issued the following statement. The news came as little shock to those who knew her.

"I am convinced that it would be a good and constructive idea if Richard and I are separated for a while. Maybe we loved each other too much—I never believed such a thing was possible....

"I believe with all my heart that the separation will ultimately bring us back to where we should be—and that's together....

"Pray for us."

Perhaps they did love one another too much. After just three years apart, the couple reconciled. Elizabeth believed Richard had cleaned up his act. They remarried in October 1975.

Unfortunately, the happy reunion was not to be. In July 1976—less than a year into their reconciliation—the couple was granted a second divorce.

"I love Richard with every fiber of my soul," she said in a statement. "But we can't be together. We're too mutually self-destructive."

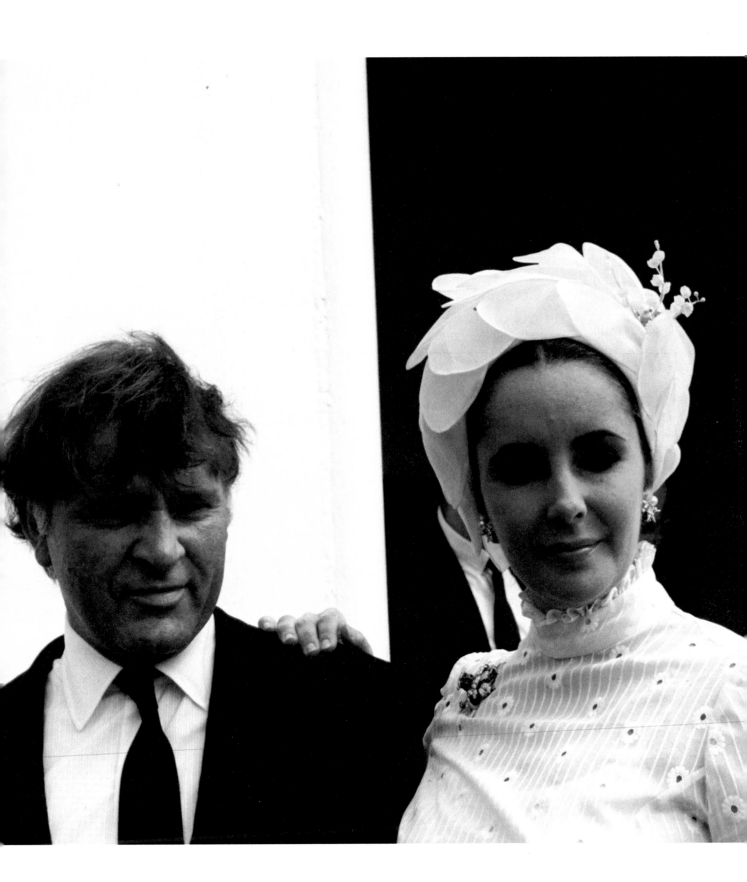

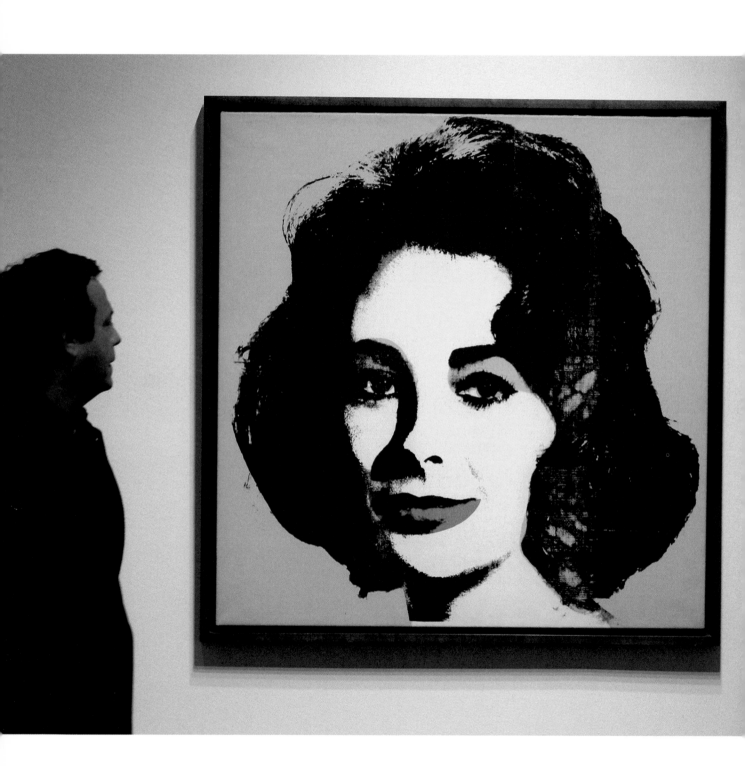

Elizabeth and Andy

As it happened, Elizabeth's celebrity preceded her. The famous artist Andy Warhol created his portrait of the movie star years before he ever met her. Simply captivated by her image, he created a lithograph of the star in his own inimitable style. It would be one of his most famous artistic works.

Years later, the two became better acquainted. Elizabeth became a regular at the New York City nightclub Studio 54 by the mid-1970s, and the two shared mutual friends in Liza Minnelli, Truman Capote, Bianca Jagger, and fashion designer Halston, among others. The spotlight for glamour was squarely on Studio 54 crowd. And of course, Elizabeth Taylor was right in the thick of things.

Warhol recognized in Taylor something he knew all too well: a supreme loneliness. "She has everything: magic, money, beauty, intelligence. Why can't she be happy?"

His vision of Elizabeth lives on. The painting was sold for auction by Christie's in 2007 for $23.5 million.

"It would be very glamorous to be reincarnated as a big ring on Elizabeth Taylor's finger."

ANDY WARHOL

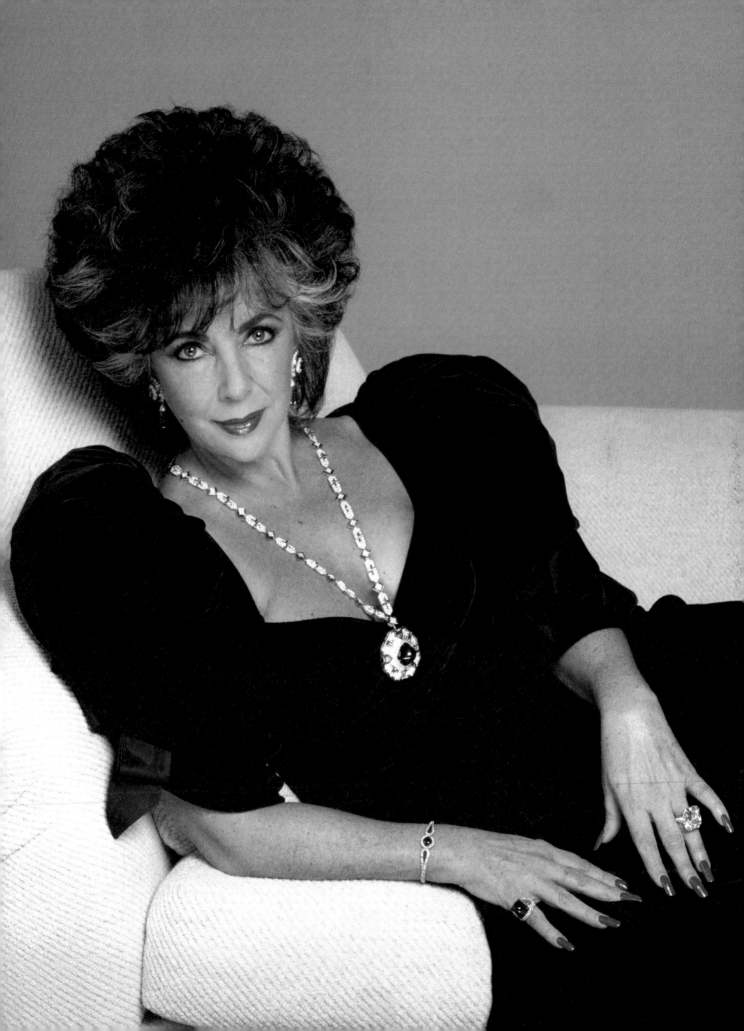

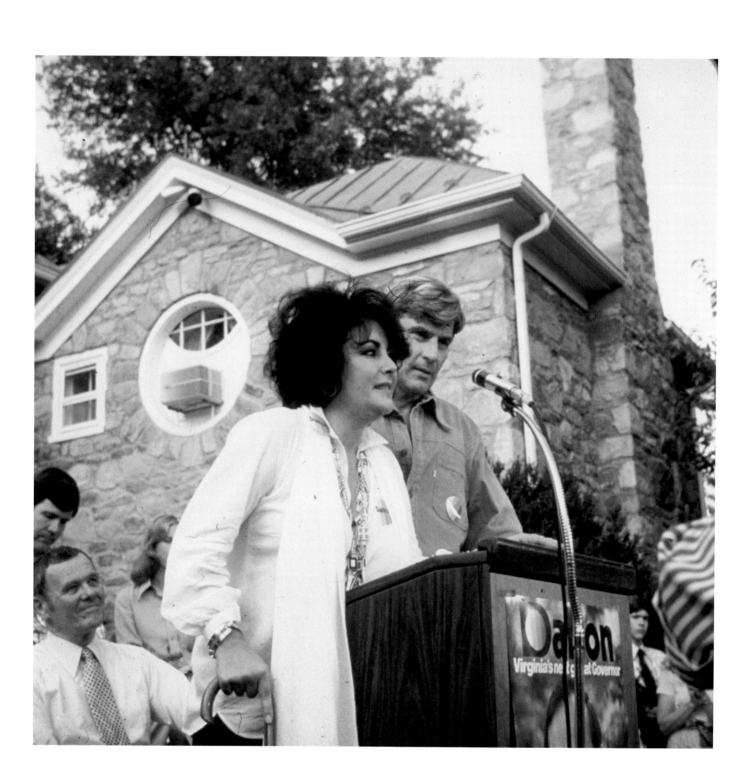

Politics as Usual

In a roundabout way, it was statesman Henry Kissinger who was responsible for introducing Taylor to her sixth husband, John Warner. Kissinger had met Taylor and her then-husband Burton and remembered being enchanted by them. Far from the Washington daguerreotype, they were refreshingly frank and humorous. Upon hearing the news of the couple's second divorce, Kissinger invited Taylor to visit Washington.

It was there that she threw herself into a social strata of a different kind. She had always been a captivating personality; in Washington, she was a force of nature.

The courtship was brief; the couple were married on December 4, 1976. Soon after, Warner announced his candidacy for the U.S. Senate. With Taylor on his arm, they hit the ground running.

"The campaign trail was harder than anything I'd done in my own career, but I have to admit there was something exhilarating about it," she later said.

Warner's bid as senator was a rousing success; the marriage, on the other hand, not so much. They lasted only a few years before calling it quits.

"Elizabeth was a great woman. We were friends until the end."

JOHN WARNER

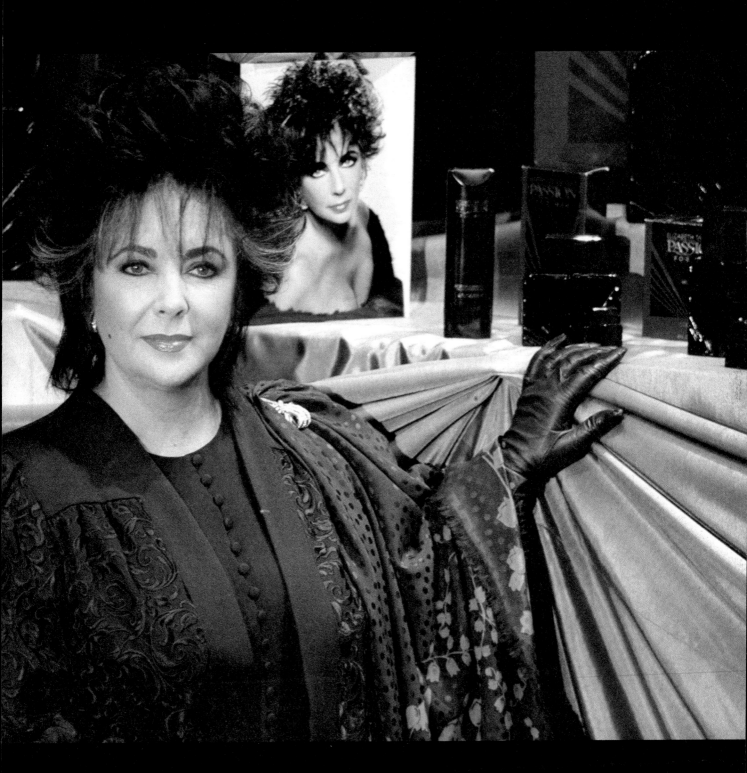

A Different Cause Célèbre

⚜ Elizabeth and Rock Hudson first met on the 1955 set of the movie *Giant*. It was a pivotal film for both of their careers, but the resultant friendship was much more important to both of them.

On October 2, 1985, Hudson succumbed to AIDS. Deeply moved by the loss of her friend and others, Taylor co-founded the American Foundation for AIDS Research, for which she had begun fund-raising earlier that year.

It was an extraordinarily unpopular subject at the time, and Taylor was ardent in pushing awareness to the forefront.

"The stakes are phenomenally high," she said at that first fund-raiser. "We hope the foundation will emerge as the national organization to support research, with the staying power to attract adequate financing and resources from the private sector. We plan to muster the talent and energy of America's brightest scientific and medical researchers to solve the mysteries of AIDS."

Since its creation in 1985, AmFAR has become just that. Acting was for the most part behind her; this was a cause Taylor would champion for the rest of her life.

"Elizabeth's legacy will live on in many people around the world whose lives will be longer and better because of her work and the ongoing efforts of those she inspired."

PRESIDENT
BILL CLINTON AND
SECRETARY OF STATE
HILLARY CLINTON

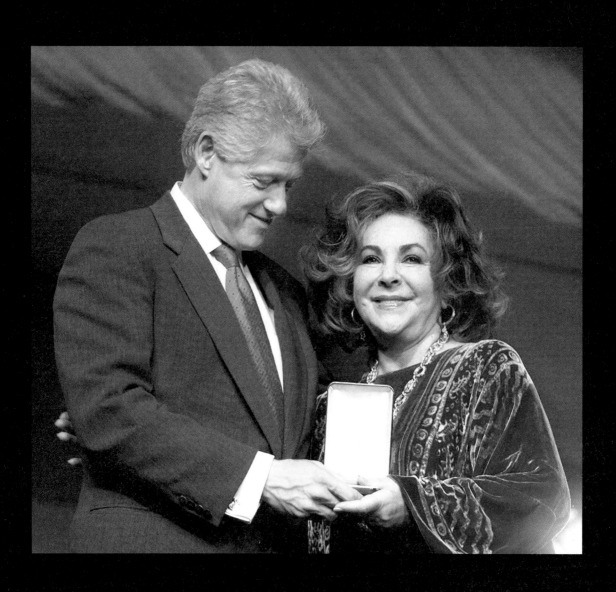

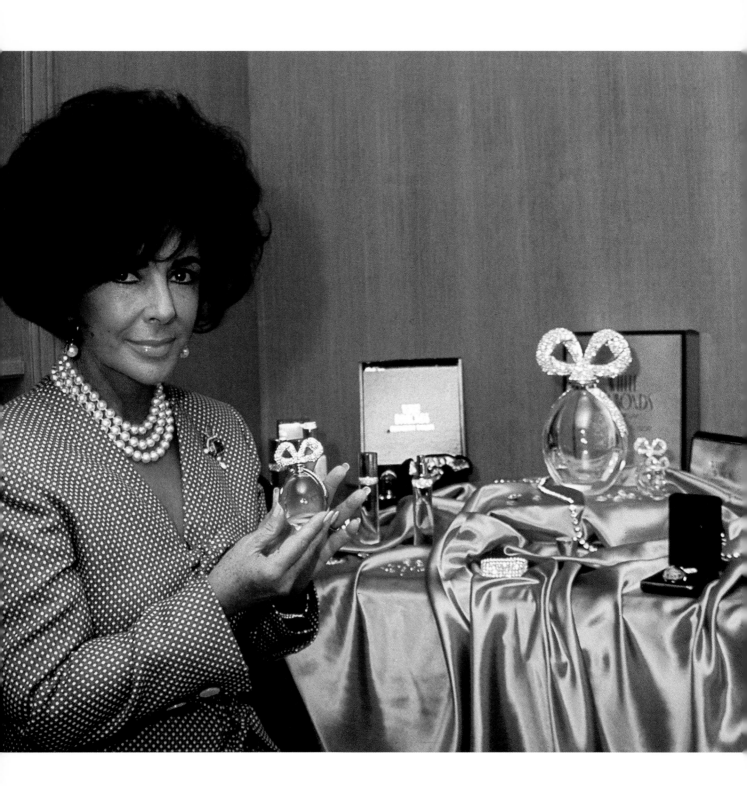

The Passion of Elizabeth Taylor

⁜ Taylor was devoting less and less of her time to acting, focusing almost exclusively on her charity work, which was more or less behind the scenes. She decided to embark on a new business venture, one which would increase her public profile anew.

It was a savvy business move on Taylor's part. Passion, which was rolled out with a $10 million marketing campaign in 1987, took off right away.

"Passion is the ingredient in me that has made me who I am," she announced. "It's my passion for life...my passion for passion that has made me never give up."

It was a risky gamble at the time. Celebrity perfumes were hardly required branding for every Tom, Dick, and Britney. The *New York Times* scoffed at the idea: "Can Elizabeth Taylor's Passion Compete with Her Friend Calvin Klein's Obsession?" the headline blared.

As it happened, it did—and then some. Taylor's perfume brand, which now includes three fragrances—Passion, Passion for Men, and White Diamonds—is the top selling celebrity fragrance line of all time, raking in over $61 million annually.

Elizabeth and Malcolm

✷ It was through the auspices of AmFAR that Malcolm Forbes first met Elizabeth. Offering a donation to her charity, he invited her to *Forbes* magazine's anniversary bash. The two hit it off immediately. According to one observer at the party, they "got on like a house afire."

The pair began to appear out together regularly—eating dinners at fine restaurants, going on lavish vacations around the world. Forbes even bought Taylor a purple Harley-Davidson as a celebration for her new perfume launch, Passion. She returned in kind, hosting his 70th birthday party in Tangier, Morocco. It was a lavish celebration. In fact, it seemed the two were doing what they could to out-lavish the other.

They insisted they were just platonic friends, but the speculation about the true nature of Taylor's relationship with the billionaire was rampant. Were they attached? Would they marry? Some had speculated that the couple were engaged. In fact, the pair even exchanged rings. But they would never marry. Instead, the relationship may well have driven her into the arms of a very different kind of man.

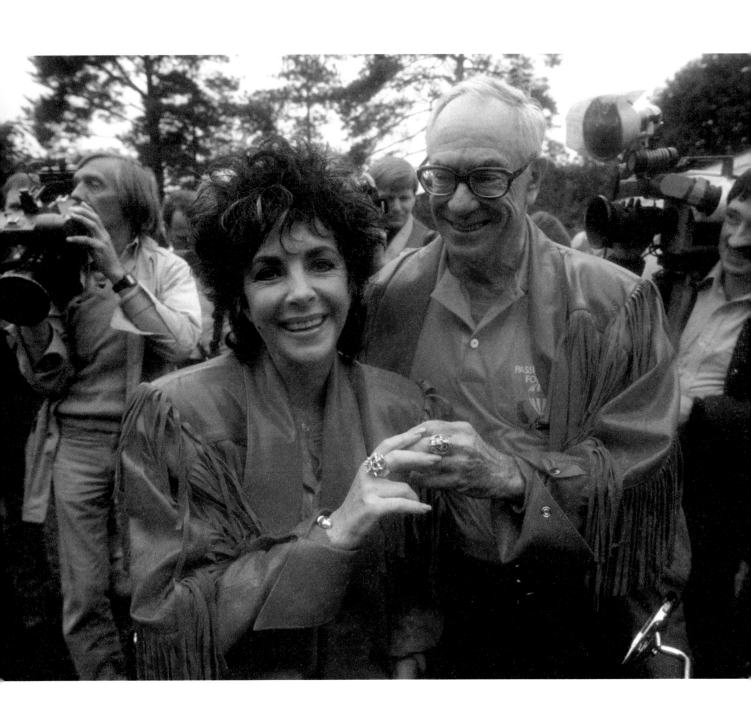

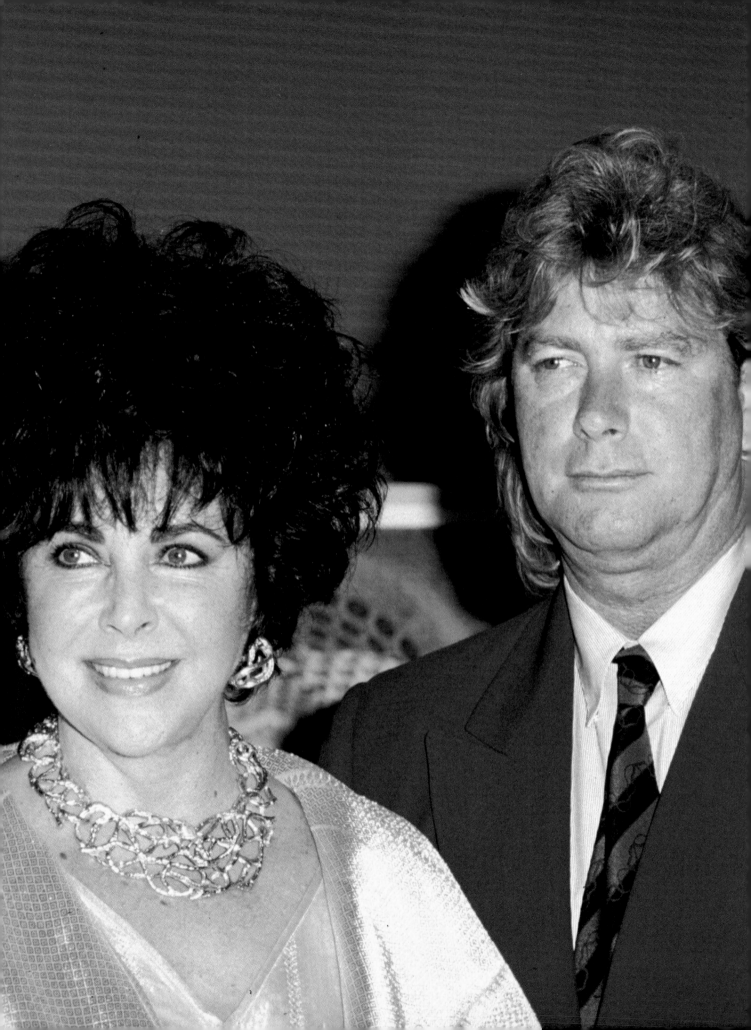

Larry Loves Liz

✖ Larry Fortensky wasn't like the rest of Elizabeth's suitors. A former truck driver and construction worker, the pair met at the Betty Ford Center, where Taylor was undergoing treatment. The two remained friends after their stints there, and became mutual support systems for one another in recovery.

Forbes was maniacally jealous of Fortensky, saying he was "not the sort of fellow you would expect to be with Elizabeth, except for the fact that he had all the time in the world to devote to her. As far as I know, he didn't waste too much time in giving up the construction business for Elizabeth."

Fortensky was at Taylor's side as she celebrated her 60th birthday at Disneyland in Anaheim, California. She gushed about him, "Larry is so supportive. We were friends for a year before we got 'together' in that sense. I saw beneath his macho exterior a great sweetness."

This time, it was Elizabeth who would do the proposing. Fortensky, 21 years Taylor's junior, and Elizabeth married in October 1991 at her friend Michael Jackson's home, Neverland Ranch. Taylor allowed exclusive rights on the story to her friend and wedding guest Liz Smith. Proceeds from the story, along with the photographs by Herb Ritts, were donated to AIDS research organizations.

Alas, it was another union not meant to last. After four years of a largely unhappy marriage, it was over. It would be Taylor's last.

Michael Jackson

⚹ Perhaps the strangest and most enigmatic of all of Taylor's friendships was her bond with music icon Michael Jackson. The two became friends in the early 1980s, after the singer had sent tickets to Taylor in the hopes she would attend his performance. It was a dream of his to meet the actress.

Soon, the two were close confidantes and "soul mates." They talked on the phone nearly every day. They shared a kinship over what they both felt was a childhood robbed from them by a life in the spotlight. "We had a similar type of childhood…. We shared a quest, in search of acceptance from an adoring public who never really knew our inner turmoil," Jackson once said.

She was a tireless defender of Jackson through all of the legal troubles he endured late in life. After his death in 2009, Taylor famously refused to attend his funeral, explaining that she didn't feel the singer would want her to share her grief with millions of others, that her heartache was "not a public event".

"I loved Michael with all my soul and I can't imagine life without him," she wrote in a statement. " I don't think anyone knew how much we loved each other. [His was] the purest, most giving love I've ever known."

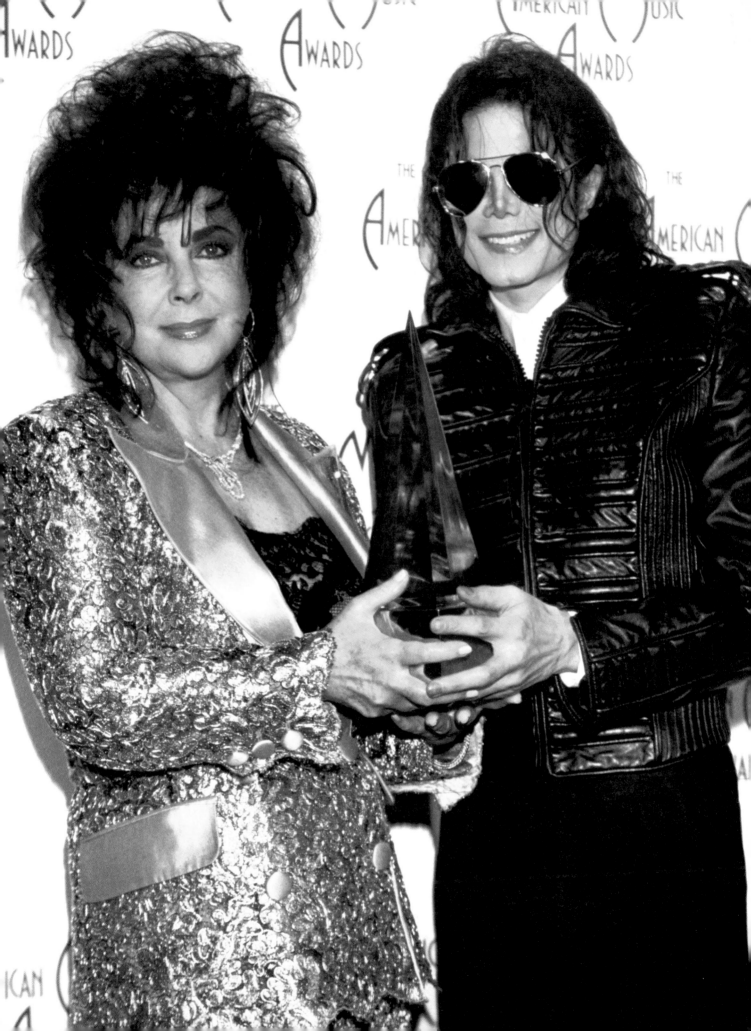

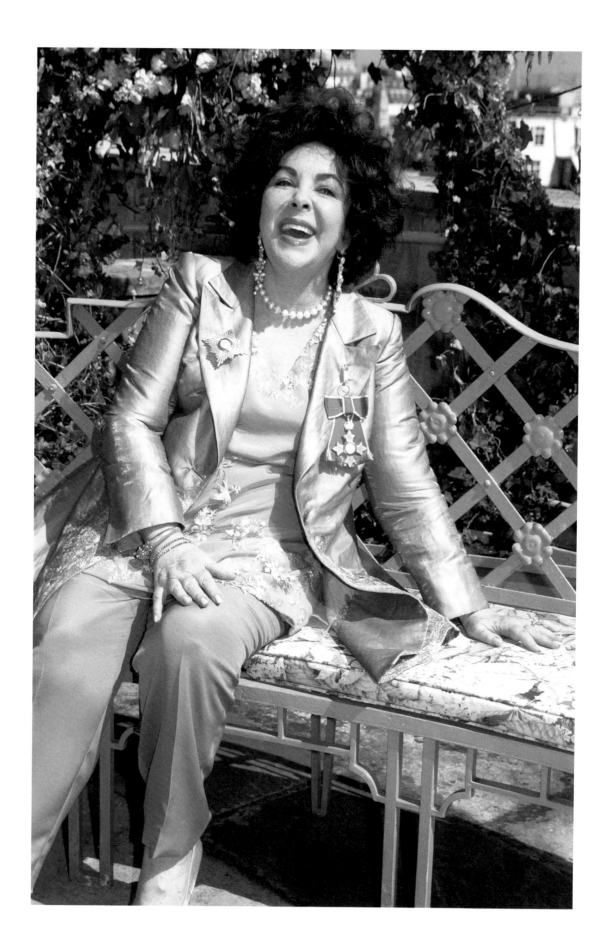

Elizabeth Becomes a Dame

✖ It is the highest honor that the English royal family can bestow. In 2001, nearly seven decades after first seeing young Elizabeth at a dance performance in London, Queen Elizabeth II bestowed the title of Dame Commander of the Order of the British Empire upon Taylor.

But it wasn't Taylor's flair for the dramatic that did it. The queen, presenting the brooch of the OBE, bestowed the title on Taylor in recognition for her tireless work in promoting AIDS awareness and research around the world. Fellow actress Julie Andrews was also on hand to be recognized.

It was with a tear in her eye that Taylor accepted the title. "Today doesn't compare to anything else that's happened to me in my life." It was a moment that she shared with her entire family—Michael, Christopher, Liza, and Maria all in attendance. That brooch was worth more than all the diamonds in the world. It was a final validation of the selflessness with which Taylor had applied herself to her chosen cause, a fitting coronation for an honorable life.

"It wasn't just her beauty or her stardom. It was her humanitarianism. She put a face on HIV/AIDS. She was funny. She was generous. She made her life count."

BARBRA STREISAND

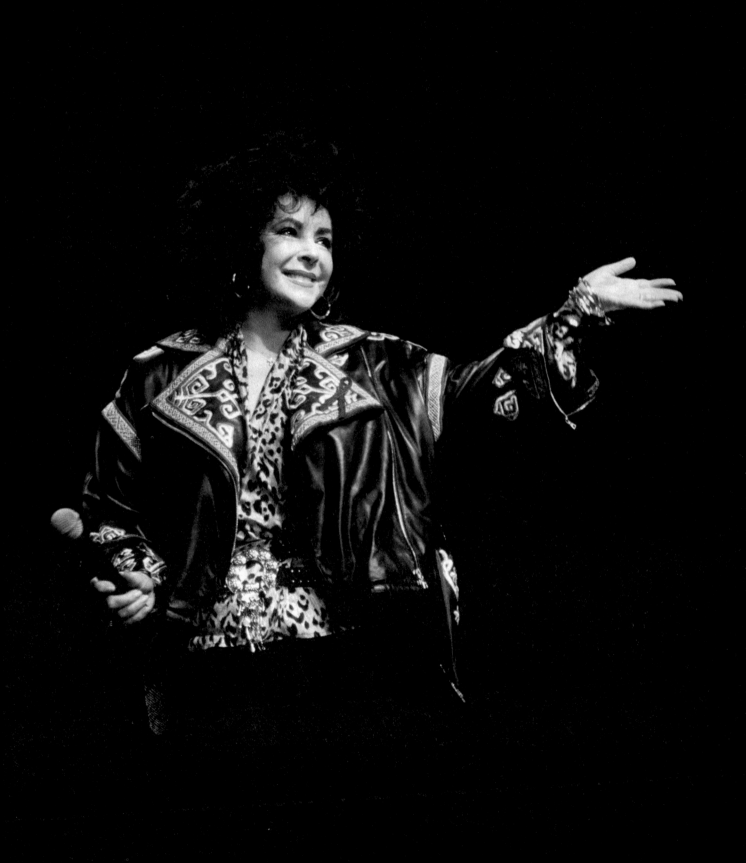

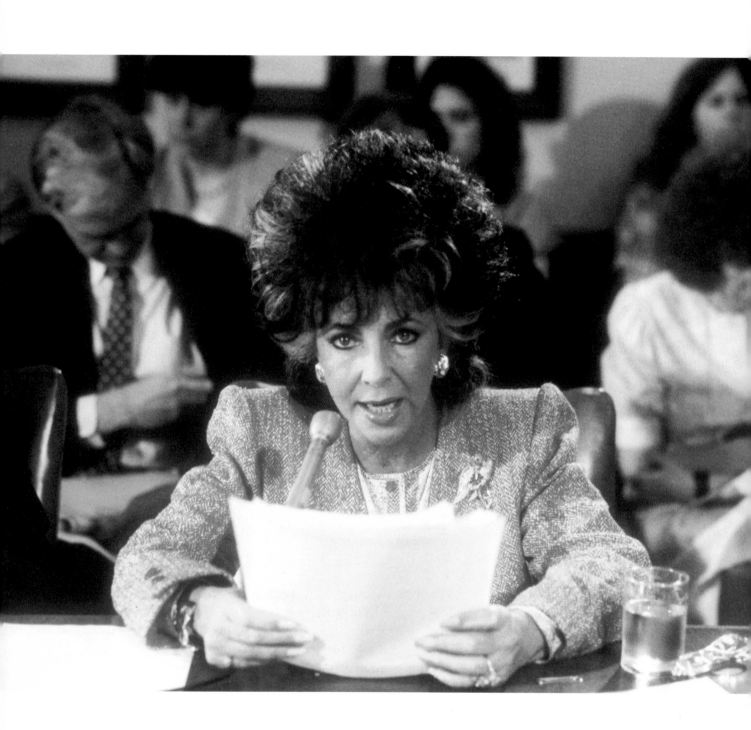

Elizabeth's Enduring Humanitarian Legacy

✖ It's hard to argue the lasting impact that Taylor's contributions to AIDS charities have had through the years. If the frequency of her recognition is any measure, then she has done much, indeed.

The British-born actress was honored by the Queen, and then by her American countrymen. President Bill Clinton presented her with the Presidential Citizens Medal in 2001 for her charity work; President George W. Bush recognized her at the Kennedy Center Honors a year later.

She won her final Oscar in 1993 when she was presented with the Jean Hersholt Humanitarian Award.

In a statement released after the actress' death, AmFAR said, "For 25 years, Dame Elizabeth has been a passionate advocate of AIDS research, treatment and care. She has testified eloquently on Capitol Hill, while raising millions of dollars for AmfAR. Dame Elizabeth's compassion, radiance, and generosity of spirit will be greatly missed by us all. She leaves a monumental legacy that has improved and extended millions of lives and will enrich countless more for generations to come."

"[Taylor was] an extraordinary ally in the movement for full equality," said GLAAD president Jarrett Barrios. "At a time when so many living with HIV/AIDS were invisible, Dame Taylor fearlessly raised her voice to speak out against injustice. Dame Taylor was an icon not only in Hollywood, but in the LGBT community where she worked to ensure that everyone was treated with the respect and dignity we all deserve."

AmFAR, the Elizabeth Taylor AIDS Foundation, and countless organizations to which Taylor devoted her time and energy will continue her efforts. Her legacy lives on.

Friends look back on the life and legacy of Elizabeth Taylor. May she forever be remembered.

"Her talent for friendship was unmatched. I don't know what was more impressive: her magnitude as a star or her magnitude as a friend. I will miss her for the rest of my life and beyond."
SHIRLEY MACLAINE

"Elizabeth, on every level, was a mensch. Kind, generous, brave."
JANE FONDA

"She was an incredible talent, and yes, she had those unforgettable eyes. I greatly admire her humanitarian efforts which have touched so many lives. Elizabeth was a very dear, generous, and loving lady."
EVA MARIE SAINT

"Elizabeth Taylor was the last of the Hollywood greats, and a fantastically charming woman. She also did a great deal in the last 25 years to help the world deal with the HIV epidemic. I am proud to have known her if only a little."
GEORGE MICHAEL

"Today my friend Elizabeth Taylor passed away. Oddly, we all knew this day was coming but still her passing took my breath away. She was a funny, loud, joke-tellin', diamond-loving, fantastic woman. She played a big role in shaping my life as Whoopi Goldberg. It really is the end of an era."
WHOOPI GOLDBERG

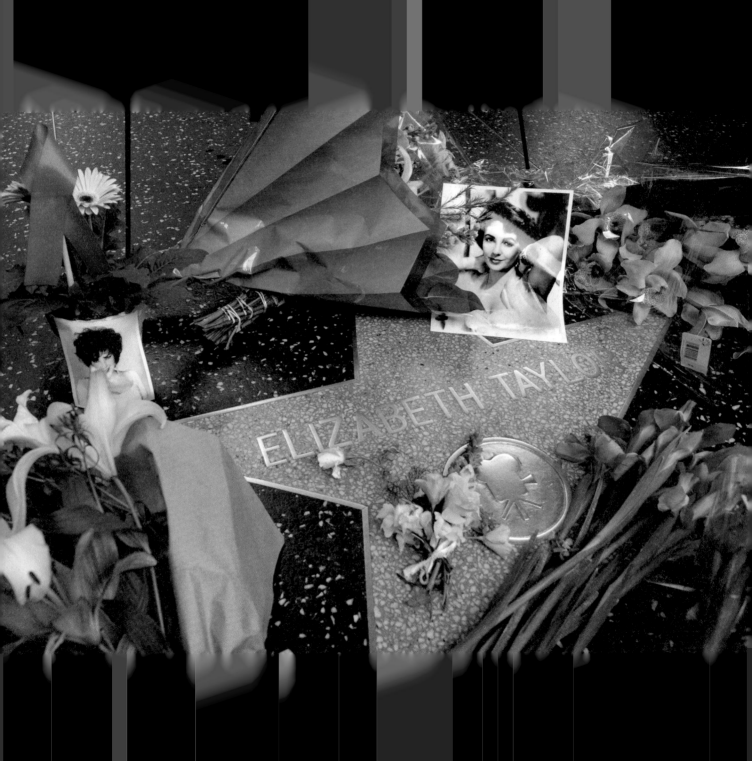

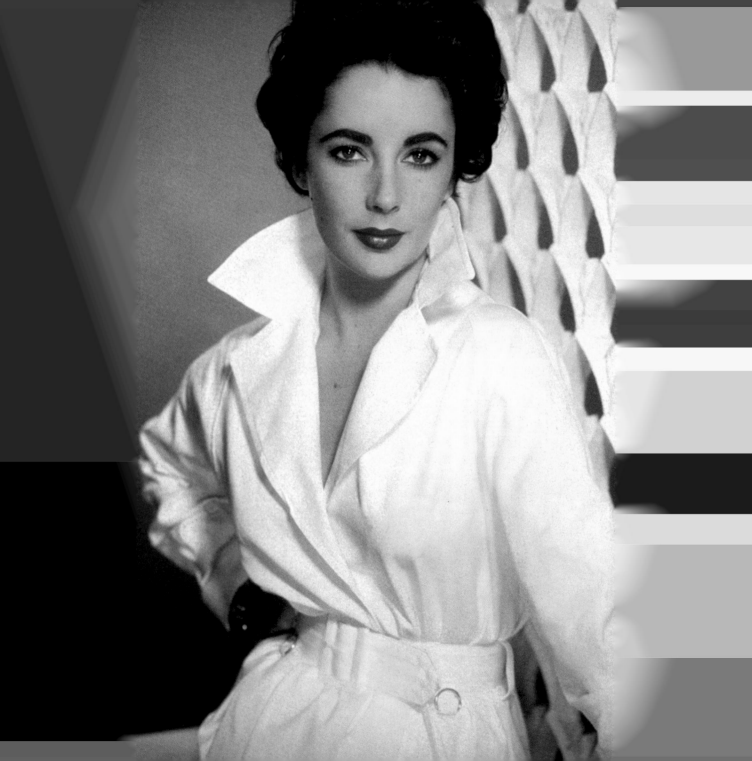

"Sad to hear of Elizabeth Taylor's death. She was the 1ˢᵗ major celebrity to join me in the fight against AIDS when it wasn't a popular cause."
JOAN RIVERS

"[Taylor was] passionate — and compassionate — about everything in her life, including her family, her friends and especially the victims of AIDS."
NANCY REAGAN

"Goddess, actress, AIDS activist, and one of the world's true beauties!"
BOY GEORGE

"It's a terrible loss. A unique talent and a singularly spectacular individual."
MARTIN LANDAU

"If my father had to divorce my mother for anyone — I'm so grateful that it was Elizabeth. This was a remarkable woman who led her life to the fullest rather than complacently following one around. She will be missed but never forgotten."
CARRIE FISHER

"We have just lost a Hollywood giant. More importantly, we have lost an incredible human being."
SIR ELTON JOHN

This book is available in quantity at special discounts for your group or organization. For further information, contact:
Triumph Books
542 South Dearborn Street
Suite 750
Chicago, Illinois 60605
(312) 939-3330
Fax (312) 663-3557
www.triumphbooks.com

Printed in U.S.A.
ISBN: 978-1-60078-665-5

Text by Katy Sprinkel
Design and page production by Andrew Burwell
Project Management by Rockett Media
Cover design by Paul Petrowsky

All interior and cover photos courtesy Getty Images